A HISTORY OF THE
ROWAYTON
WATERFRONT

A HISTORY OF THE
ROWAYTON
WATERFRONT

ROTON POINT, BELL ISLAND & THE NORWALK SHORELINE

KAREN JEWELL

Published by The History Press
Charleston, SC 29403
www.historypress.net

Copyright © 2010 by Karen Jewell
All rights reserved

First published 2010

Manufactured in the United States

ISBN 978.1.59629.691.6

Library of Congress Cataloging-in-Publication Data

Jewell, Karen.
A history of the Rowayton waterfront : Roton Point, Bell Island, and the Norwalk shoreline
/ Karen Jewell.
p. cm.
Includes bibliographical references.
ISBN 978-1-59629-691-6
1. Rowayton (Conn.)--History. 2. Norwalk (Conn.)--History. 3. Waterfronts--Connecticut--Rowayton--History. 4. Waterfronts--Connecticut--Norwalk--History. 5. Rowayton Region (Conn.)--History, Local. 6. Norwalk Region (Conn.)--History, Local. 7. Long Island Sound (N.Y. and Conn.)--History, Local. I. Title.
F104.R76J49 2010
971.8--dc22
2010023810

Notice: The information in this book is true and complete to the best of our knowledge. It is offered without guarantee on the part of the author or The History Press. The author and The History Press disclaim all liability in connection with the use of this book.

All rights reserved. No part of this book may be reproduced or transmitted in any form whatsoever without prior written permission from the publisher except in the case of brief quotations embodied in critical articles and reviews.

CONTENTS

Acknowledgements 7
Introduction 9

1. The Basics 11
2. Of Islands and Lighthouses 15
3. The Norwalk Yacht Club: A Foundation for Tradition 25
4. Roton Point: "The Most Charming Watering Place on the Sound" 37
5. The Great Hurricane of 1938:
 "The Long Island Express" Barrels across the Sound 53
6. Hickory Bluff and the Rowayton Yacht Club:
 An Era Remembered 57
7. Bell Island: The Summer Resort at the Tip of Rowayton 75
8. Rex Marine and Norwalk Cove Marina:
 Louis J. Gardella Has a Vision 87
9. Mysteries and Treasures: A Missing Ship, the Curse of
 Captain Kidd and a Bounty of Precious Jewels 95
10. A Bit about Oysters 105
11. Multihulls Make Maritime History 111
12. The Waterfront Today 117

Bibliography 121
About the Author 125

ACKNOWLEDGEMENTS

In the process of writing this book, I quickly realized the great importance of the many resources and extensive support system necessary to complete a project of this type. Although I would love to be able to thank everyone who contributed in even the smallest of ways, I would especially like to acknowledge a few of those who truly helped to make this project a pleasure to work on. In no particular order, I would like to extend my sincere gratitude and appreciation to:

Clive Morrison, whose generosity in sharing his comprehensive personal collection of all things Rowayton was far and above the call of duty; Bill Gardella Sr., for taking the time out of his busy schedule to fill me in with some wonderful stories about the history of Rex Marine and Norwalk Cove Marina; Bill Gardella Jr., for fielding numerous phone calls from me with the utmost patience; Jill Leonard Tavello, for digging up and providing the vintage Ascension Beach Water Ski Club photos; Scott Clingenpeel, who continues to always be there for my nautical needs; Nancy and Ron Borge, for helping me out in too many ways to list; Pat McCloskey, for her efficiency and proficiency with the red pen that kept me on schedule; and my mother and father, whose support and encouragement throughout the entire project went far beyond what any words could ever express.

INTRODUCTION

There is a classic Norman Rockwell painting that depicts an elderly gentleman sporting a captain's hat and jacket as he stands with his arm draped around the shoulder of a young boy wearing a sailor's suit. The two of them, along with the boy's dog, are peering out at the sea, watching as majestic ships sail off in the distance. The retired captain is no doubt telling some fascinating nautical tale from his past to his captivated audience. This enchanting scene is appropriately titled *Looking Out to Sea*.

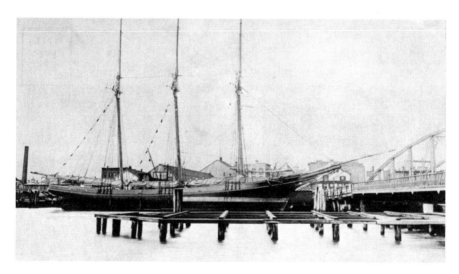

The lumber schooner *Edward W. Young* in Norwalk Harbor. *Courtesy of Clive Morrison.*

Introduction

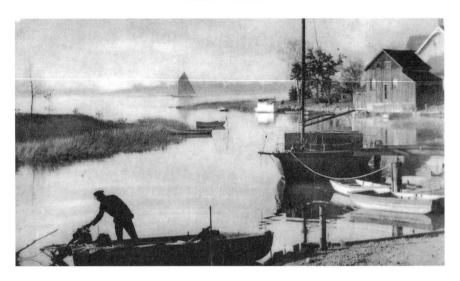

A quiet morning along the Norwalk waterfront. *Courtesy of Clive Morrison.*

There is something to be said for our maritime heritage and the "ol' salts" who enjoy sharing their experiences and stories of a bygone era. Without them and their invaluable knowledge and insights, our connection to the past would be lost and with it, the foundation for our future.

A History of the Rowayton Waterfront is a way to feel that connection to a very special corner of Long Island Sound situated along the Connecticut coast. Rich in history, the area that comprises Rowayton, Roton Point, Bell Island and the surrounding Norwalk shoreline remains one of the premier destinations on the eastern seaboard, just as it has been for hundreds of years.

As you read along, you will learn interesting facts that you may or may not have heard before, and you will have a unique opportunity to catch a glimpse inside the fascinating personal accounts of those who remember the old days.

So sit back, enjoy and have a listen to what the ol' captain has to say.

I
THE BASICS

In the autumn of 1650, a group of ambitious Connecticut settlers purchased a section of land located between what are now the Norwalk and Saugatuck Rivers from a gentleman by the name of Roger Ludlowe, who had owned the property since 1640.

On February 13, 1651, the same assemblage of colonial businessmen went on to acquire the property that ran from the Norwalk River to the Five Mile River from Chief Runckinheague of the Siwanoy Indian tribe. Collectively, the two territories were named "Norwauke," and on September 11, 1651, the Hartford Legislature of Connecticut officially proclaimed that "Norwauke shall bee a Towne." With this proclamation, the section we now call Rowayton was also born and would become a thriving and active subcommunity within the newly recognized town.

"Norwauke," which ultimately evolved into "Norwalk," is a derivative of a combination of the Algonquin Indian word for "point of land" (*Noyank*) and the Native American words *Norowake* or *Norwaake*, which mean "Native American chief."

When describing where the town border began and where it ended in the days before more sophisticated means of measuring distances were invented, it was simply explained as "a day's walk north from the sea."

Originally inhabited mostly by farmers and fishermen, Norwalk would soon attract a new influx of residents that included skilled blacksmiths, carpenters, shoemakers, shop owners, hotel entrepreneurs, dairymen, sea captains and even an American spy or two.

A History of the Rowayton Waterfront

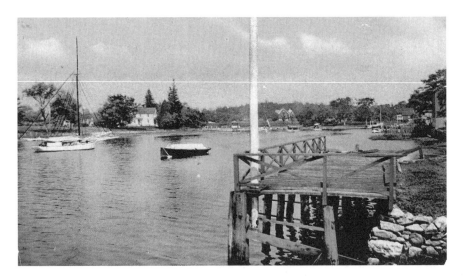

Rowayton Harbor. *Courtesy of Clive Morrison.*

One such spy was a young soldier in the Continental army by the name of Nathan Hale. His efforts during wartime earned him the reputation of being a true American hero. Born in Coventry, Connecticut, in 1755, Hale would cover much ground with his duties as both a warrior and an undercover scout for the American government.

On a fateful day back in 1776, Nathan Hale set out by ship from Norwalk on what would ultimately turn out to be his last intelligence-gathering mission. While attempting to penetrate the British navy, which was preparing for an attack on Long Island Sound, Hale was captured and hanged. Hale was a dedicated soldier who loved serving his country. His final words before drawing his last breath clearly reflected his loyalty and have forever been etched in history. He pronounced, "I only regret that I have but one life to lose for my country." The current-day Nathan Hale Middle School in Norwalk was named in honor of this fallen hero.

As the American Revolutionary War continued, much havoc was wreaked along the Norwalk shoreline. On July 10, 1779, British forces made landfall and proceeded to almost completely destroy the town as they attempted to burn it to the ground. Once all was said and done, only six homes remained standing. Although the level of destruction was massive, the residents of Norwalk would eventually recover and go on to become a flourishing and vital community.

The Basics

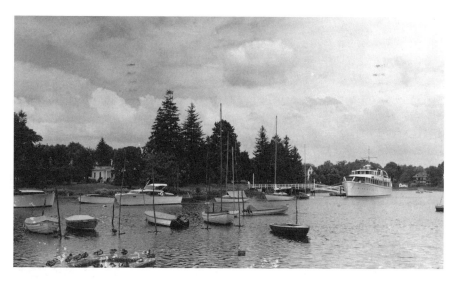

Both sail- and powerboats moored on the Five Mile River. *Courtesy of Clive Morrison.*

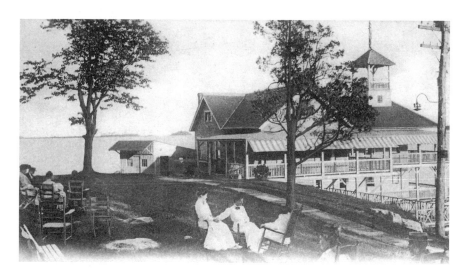

A quiet afternoon along the Norwalk waterfront. *Courtesy of Clive Morrison.*

In 1849, the New York and New Haven Railroad began offering train service through Norwalk. In 1852, the Danbury and Norwalk Railroad added to the accessibility by connecting those two towns. Eventually, one railroad system would emerge, calling itself the New York, New Haven and Hartford Railroad. This new means of transportation greatly opened up

A History of the Rowayton Waterfront

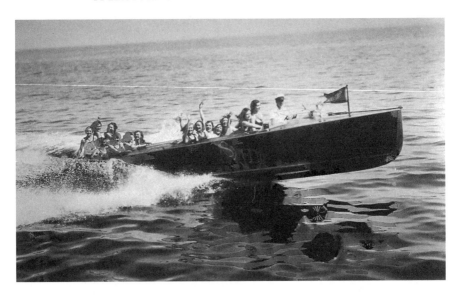

Powerboating in Norwalk Harbor. *Courtesy of the Roton Point Association.*

the possibilities for economic growth in Norwalk. Trolley cars and gasoline-powered automobiles soon replaced the horse and buggy, helping to create an even more vibrant industrial environment.

The profession of oyster farming thrived from the late 1800s to the early 1900s, earning Norwalk boasting rights as the "oyster capital of the world."

During the early 1900s, one of the most celebrated fairgrounds in the history of the United States prospered and entertained thousands of visitors a year on the property of Roton Point, overlooking picturesque Long Island Sound. Some of the most magnificent ships in maritime lore decorated the horizon just beyond the shore.

Life was indeed grand at the turn of the century along the Connecticut shoreline. That time in history would eventually become known as the "Golden Age of Transportation," as it was the ability to travel that greatly improved the opportunity for commercial profit.

These are just a few basic facts about how Norwalk and Rowayton got their start. Now that the foundation has been laid, let us take a closer look at what life was truly like along the waterfront during those early days and learn more about what happened throughout the ensuing years in what will always be remembered as a magical time in history.

2
OF ISLANDS AND LIGHTHOUSES

Coastal Connecticut sits along the shores of Long Island Sound, with amazing and unrivalled views of its unique seascape. Although Long Island Sound now boasts dimensions of about 110 miles in length, 23 miles in width and some 787,000 acres in overall coverage, it began merely as a small river tens of millions of years ago.

During its evolution, the sound assumed the roles of valley, glacier, lake and, ultimately, the grand estuary it is today. Over the years, scientists have used submarines, sonar devices, drills and remote-controlled vehicles to try and uncover the exact history of the sound. Their discoveries have taught us that beneath its muddy floor can be found beach ridges that extend from the center of the water out toward land. These "rings," as they are more commonly referred to, represent the gradual expansion of water levels throughout the centuries.

Shoreline cliffs continue to hide some of the dark-hued clay that was prominent during its years as a freshwater lake. The shells of sea animals can still be found deeply embedded in the floor of the sound from its time spent as a valley filled with streams and river channels.

As a young river, it formed smaller streams that extended to Long Island and ultimately created a fascinating selection of harbor inlets. However, once the glacier movement started to head south from Canada, the valley really began to change shape.

It is guesstimated that sheets of ice close to one thousand feet high slowly pushed away great amounts of rocks and sand, which in turn formed ridges

on Long Island. These ridges, known as terminal moraines, show us where the glaciers stopped before they eventually continued their recession.

Since the Long Island glaciers did not recede in a consistent fashion, they created new ridges as they retreated on their way out. These are known as recessional ridges. In essence, these ridges represented the spots where the glaciers took a break before moving on.

The last glacier to finally leave the area left behind a series of lakes from New York to Massachusetts nearly twenty-three thousand years ago. These lakes were collectively referred to as the Glacial Lake Connecticut. Scientists believe that about three thousand years after the birth of Lake Connecticut, erosion caused the water to slowly drain through a moraine ridge near Fishers Island, New York. For a brief period, parts of the valley reappeared, but these were soon washed over as the rising sea levels from the Atlantic Ocean began to pass through the same opening, only in the opposite direction.

As a direct result of the effects of the glacial age, Norwalk now boasts an impressive and interesting array of some twenty-plus islands that sit just a short distance from its shoreline in the heart of Long Island Sound. Counting them all, the total ensemble includes Sheffield Island, Shea Island, Copps Island, Chimons Island, Betts Island, Long Beach Island, Grassy Island, Goose Island, Crow Island, Hoyt Island, Tavern Island, Peach Island, Sprite Island, Calf Pasture Island, Tree Hammock Island and a series of smaller islands that complete the chain.

In 1614, a Dutch navigator by the name of Adriaen Block was exploring the waters off of the Connecticut shoreline aboard the ship *Onrust*. When he came across the islands around Norwalk, he proclaimed them to be the Archipelago Islands.

Through further exploration, Block soon discovered that these land masses were abundant in an assortment of trees, shrubs and grasses that included black cherry, sassafras, juniper, blackberry, Asiatic bittersweet, Japanese honeysuckle, Russian thistle, seaside goldenrod, switch grass, salt marsh and salt meadow cordgrass, spike grass, black grass and sea lettuce.

The bird family was also well represented amongst the island chain. Black-crowned night herons, great egrets, snowy egrets, little blue herons, yellow-crowned night herons, green herons, piping plovers, least terns, common terns, Roseate terns, American oystercatchers, black-backed gulls, herring gulls, double-crested cormorants, American black ducks and glossy ibis all continue to fly and nest throughout the Norwalk islands.

Betts Island, which is located about four hundred yards north of Chimons Island, was once used as a watch station for oystermen. Thirty-four of the local

Of Islands and Lighthouses

oyster growers bought the land mass in 1874 with a common interest to protect their oystering grounds. The co-owners set up a revolving schedule of watch keeping from a small house that they had built on the island. In September 1929, Captain Frederick F. Lovejoy and Clarence E. Merritt purchased Betts Island from the Betts Island Company. It remains a privately owned island today.

Chimons Island, the largest of all the Norwalk islands at fifty-nine acres, boasts more than three acres of beachfront property. Sitting prominently in the middle of the chain, Chimons was once called Mamachimons after a local Indian chief. Chimons Island is currently a part of the Stewart B. McKinney National Wildlife Refuge.

Calf Pasture Island, which sits only one thousand yards to the southeast of Calf Pasture Beach in East Norwalk, holds the honor of being the first officially recognized island of the group. It was once the grazing ground for Norwalk cattle, which were herded through the water at low tide by the early settlers. Calf Pasture Island was also the first to be readily used by the community for both commercial and recreational enjoyment.

Peach Island, situated some one hundred yards from the waterfront of South Norwalk, has had its share of private owners over the years. Interestingly, it has been the location of many tragedies. One such tragedy occurred in 1926, when Effinger White and Frank Thompson drowned in a storm after their boat was overturned not far from the island's shore.

Calf Pasture Beach in East Norwalk. *Courtesy of Clive Morrison.*

A History of the Rowayton Waterfront

On December 8, 1928, Alton W. "Bink" Reynolds, an electrical contractor and accomplished athlete, along with his friend Herbert Preston, a local painter, also drowned after duck hunting on the island. As often happens on the water, the weather had unexpectedly turned, and it was stormy when the men departed the island en route back to the mainland. It is believed that their vessel capsized just a couple hundred yards from the island. Bink's fifteen-year-old son, Alton W. Reynolds Jr., was also with the two men but was apparently rescued after clinging to the overturned vessel for more than three hours in the turbulent seas. Today, Peach Island is part of the McKinney Wildlife Refuge.

Tavern Island, also known as Pilot Island, is located about five hundred yards from the Wilson Point area of South Norwalk and about one thousand yards north of Sheffield Island. At one point in time, Tavern Island was owned by Dr. Parker and Dr. Lambert, both of New Canaan, who used it as a second home during the warmer seasons.

In the early 1840s, Parker and Lambert leased the property to Captain Nathan Roberts. In 1848, Captain Roberts built a house with a colleague, Oliver W. Weed, that was eventually rented out to Pilot Joseph Merrill. Aside from earning some extra cash from their tenant, Roberts and Weed cultivated about one-third of the island for farming. Today, Tavern Island is home to a private mansion with elegant walkways and impeccably groomed grounds.

Sprite Island, situated about seven hundred yards to the north of Calf Pasture Island, was the summer residence of a successful New York City financier during the 1940s. The New York–based owner was known for breeding collies and often exercised the canines with a twenty-minute walk around the perimeter of his property. Sprite Island is a seven-acre landmass that has a rocky bluff at one end and a rather small protected and rocky beach at the other. In 1952, the financier sold the land. It is currently being used as the home for the Sprite Island Yacht Club. Sprite Island, the highest point on the Connecticut shoreline, continues to retain the luxurious landscape and natural beauty it was known for during the days when the financier's magnificent mansion stood on its grounds.

Although all of the islands have a unique history unto themselves, probably the most recognizable is the fifty- three-acre Sheffield Island, home of the famous Sheffield Lighthouse. Sheffield Island was once the property of the Norwalk Indian sagamore Winnipauk. It actually went by the name of Winnipauk Island until it was deeded to the Reverend Thomas Hanford, Norwalk's first minister, on December 2, 1690, as a token of friendship.

Of Islands and Lighthouses

Winnipauk offered it as "my island of land lying against Rowerton, containing 20 acres more or less [as estimated at the time] bounded on ye east with ye island Mamachimons, and Cochanenas and on ye west with the point of Rowerton." After that transaction, the island went through several different name changes in the ensuing years, including stints as Long Island, Little Long Island and White Island.

In 1804, Captain Robert Sheffield of Stonington, Connecticut, purchased the land for the presumed sum of $6,000. The island was once again renamed, this time to Sheffield, and has remained so ever since.

In later years, Gershom Smith, son-in-law of former proprietor Captain Sheffield, bought the island. In 1818, shortly after purchasing the property from his wife's father, Smith put up a hotel, or as he called it, a "house of entertainment." In addition to his duties as an innkeeper, Smith also spent much of his time cultivating the land and raising cattle. Many times, Smith's herd could be seen walking to neighboring islands when the tides were low.

In 1827, Smith assumed the role of lighthouse keeper when a navigational beacon was erected on the island in order to forewarn seafarers of the many dangerous shoals and ledges that surrounded the entrance to Norwalk Harbor.

That first lighthouse had a unique and somewhat complex lighting system. The original design consisted of ten lamps that each housed parabolic reflectors. These lamps were then turned in succession using a clocklike mechanism. As the lamps rotated, an alternating series of red and white flashes would project from the top of the lighthouse.

In 1850, an inspection of the lighthouse produced the following status report:

> *Lantern apparatus was clean, and so was everything in and about the light-house; lamps are in good burning order, but the reflectors are poor...Keeper is alone, entirely so, and everything he has in the house is out of fix; nothing is done right; nothing is as it should be. Poor man, and miserable, and will continue so without a wife.*

In 1857, the lamps were replaced with a newer fourth-order Fresnel lens.

By 1900, the Sheffield Light had a new keeper by the name of Samuel Armour. In 1901, Armour became quite ill with typhoid fever after consuming contaminated water from the light station's cistern. It would take Armour three months to fully recover. During his long illness, Armour's wife assumed all of the responsibilities and kept the light running until her husband's return to good health.

A History of the Rowayton Waterfront

After nearly seventy-five years of service, the Sheffield Light was eventually replaced by the Greens Ledge Light, which was positioned a bit farther west of the harbor entrance. In February 1902, the Greens Ledge Light began working as the official beacon of Norwalk Harbor.

During the 1930s, Sheffield Island almost became the site for an exclusive resort, complete with tennis courts and a golf course. However, due to the inability to supply the island with sufficient amounts of fresh water, the plans were ultimately abandoned.

Sheffield Island has quite a colorful past that at times appears to enjoy revealing itself to current-day visitors. In 1991, archaeologist Karen Orawsky was hard at work at a preservation site located on the island when she suddenly heard "hypnotic and mystical" music coming from somewhere nearby. From all that she could gather, there was no credible explanation for where the sounds were coming from.

At other times, Orawsky would hear the distinct echo of a foghorn, yet there was no physical foghorn on the island to speak of. What really gave her the chills, however, were the cries for help that she would hear on occasion in the distance. Her attempts to follow the screams of desperation were to no avail; the eerie yells led her to no place in particular, and there were never any visible signs of other people in the vicinity.

Many believe that these were all the pranks of the restless spirit of the late Captain Sheffield. There has yet to be any explanation to prove otherwise.

One of the reasons that the Sheffield Light was to be replaced by the Greens Ledge beacon was because of the innate and integral positioning of Greens Ledge itself. Greens Ledge was located just west of Sheffield Island and was a little over a mile in length and about one hundred yards wide. At that locale, and with those specifications, it naturally created one of the most dangerous marine configurations near Norwalk Harbor.

The initial proposal to erect a light there was presented in 1889. However, it was not until ten years later, in 1899, that Congress granted $60,000 for the funding of such a light. When the Greens Ledge Light was finally completed in 1902, the Sheffield Light was officially retired. The former Sheffield Light was auctioned off in 1914 to Thorsten O. Stabell, captain of the Norwalk Yacht Club at that time.

The design of the Greens Ledge Light resembles a cast-iron tower placed on top of a cylindrical cast-iron and concrete-filled foundation. In essence, it looks like a spark plug, as it was appropriately nicknamed. The original light was installed with a fifth-order Fresnel lens that flashed a red light every few seconds. However, just three months later, it was replaced

Of Islands and Lighthouses

with a fourth-order Fresnel lens that displayed a white light with a red flash every fifteen seconds.

The first light keeper at Greens Ledge was William DeLuce. DeLuce worked at the light from 1902 until 1908.

In 1909, a Swedish gentleman by the name of John Kiarskon applied for the position of assistant keeper. After a brief stint as assistant, Kiarskon was quickly promoted to head keeper.

On March 2, 1910, Kiarskon departed the lighthouse in the station's only boat to go to the mainland to presumably pick up provisions and to cash paychecks for him and his assistant, Leroy C. Loughborough. After many hours, it became increasingly apparent to Loughborough that Kiarskon was not going to return.

Eleven days later, the light station's boat drifted ashore, with Kiarskon inside, only as Loughborough described it to the *Washington Post*, he was "half-starved, exhausted and almost crazy." When asked how he had survived at the light for so long without supplies, Loughborough replied that he had lived on potatoes and dog biscuits, with only boiled salt water to drink.

Without the principal keeper to guide him, Loughborough had labored with maintaining operation of the light for those eleven long and stressful days. For three days, Loughborough was unable to sleep or eat for fear of the engines failing. At one point, during a seventy-two-hour stretch, there remained a relentless fog, at which time one of the engines broke down. While attempting to fix the engine, the main beacon burned itself out. When a crew from the mainland arrived to see why the light had not been visible, they found Loughborough nearly unconscious on the floor with his dog beside him.

When the truth finally came out about Kiarskon's unexplained failure to return to Greens Ledge Light that day, it was obvious that the head keeper had something to hide. It turned out that Kiarskon had gone to a local hotel, cashed his assistant keeper's paycheck of $44.69 and proceeded to drink the money away. Kiarskon eventually turned himself in to the authorities, at which time he was dismissed as the keeper of the light and was brought up on charges of forgery.

Upon returning to the mainland, assistant keeper Loughborough declared:

> *I feel ten years older and my hair has grown gray. I would not go through that experience again for the United States mint. Several times I inverted the flag on the mast, intending to attract the attention of some passing boat and thereby escaping to the mainland, but the greater part of the time, it was so stormy or foggy the signal could not be seen. Each time I would take*

it down, determined to stick it out to the end. I was almost out of my head from the strain. It would not have been so bad save for the awful fog, which made me keep at the engines night and day. It is well that the "Pansy" came when she did. I don't think I would ever have moved from that rug.

Loughborough ultimately received well-deserved accolades for his heroism in the face of abandonment and potential starvation. Sadly, though, Loughborough never fully recovered from his ordeal. In February 1911, the former assistant light keeper died of tuberculosis at his father's home in Point Judith, Rhode Island, at the age of twenty-seven.

William T. Locke would become the next head light keeper at Greens Ledge, and Loughborough's brother George was appointed his assistant.

Now here's an interesting twist to the ongoing Greens Ledge Light saga. In March 1912, George Loughborough went ashore to South Norwalk. While there, he found out that his aunt, who lived in Wakefield, Rhode Island, was quite ill, so he immediately left to go to her side. Loughborough was gone for sixteen days, leaving the head keeper alone at the light. After more than two weeks manning the beacon solo, Locke was discovered weak and exhausted. He stated that he had had little sleep since Loughborough left and that he had rationed his food in order to survive.

Locke recovered much better from his experience than the assistant keeper's brother had two years earlier. However, assistant keeper George Loughborough did lose his job—understandably so.

The assistant light keeper's position was filled shortly after that incident by Frank Thompson. On a cold February day in 1917, Thompson rowed to the mainland for some supplies. As he was heading back to the light in the early afternoon, his boat suddenly became trapped in the ice. Unable to free the vessel, Thompson soon found himself being pulled out farther into Long Island Sound by the ebbing tide. Fortunately, a resident of South Norwalk who was looking toward the water at the time happened to notice the trouble that Thompson was in and immediately called the local authorities. At 10:30 p.m., a nearly frozen Thompson was finally rescued by the Bridgeport Towing Company and brought safely home.

As the years have gone by, countless storms have challenged the constitution of the Greens Ledge Light, especially the powerful hurricane of 1938. As a result, the beacon developed a bit of a tilt. Once this became noticeable to the keepers, they began to complain about the fact that all of their furniture would collect on one side of the light whenever the generators were running (apparently due to the vibrations of the motors

Of Islands and Lighthouses

and the "new" angle of the beacon tower). They ultimately fixed their problem by only putting the furniture on one side to begin with.

Greens Ledge Light remains in operation as a navigational aid today.

The construction of Pecks Ledge Light was originally suggested in 1896 to help guide mariners around the eastern end of the Norwalk islands. In 1902, the proposal was finally accepted. Unknown at the time, the Pecks Ledge Light would be the last fully staffed beacon built on Long Island Sound. After twenty-seven years operating in that capacity, it would eventually be replaced by an automated system.

In 1901, a $10,000 grant had been awarded for a conservative design of the Pecks Ledge Light, but when it was determined that there would be two keepers staying there full time, an additional $29,000 was allowed. Construction finally began in the summer of 1905.

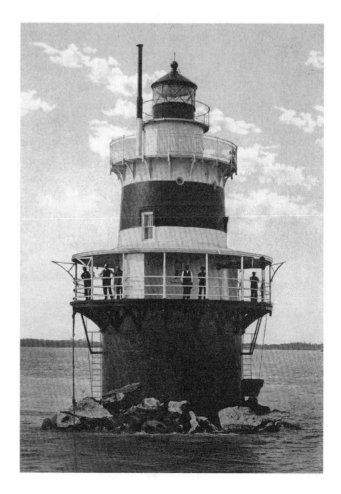

Pecks Ledge Lighthouse. *Courtesy of Clive Morrison.*

Pecks Ledge Light was built similarly to the spark-plug design of Greens Ledge Light. Its lantern was originally constructed with a fourth-order Fresnel lens that flashed an alternating white light. The interior of the structure was made up of three stories of living space for the keepers, while the top floor was where the lantern and watch room were placed. There was also a basement included in the plan where cisterns used for catching rainwater could be stored.

The first head light keeper of the Pecks Ledge beacon was George W. Bardwell. Bardwell earned an annual salary of $600.

In February 1913, a new light keeper by the name of Conrad Hawk was working on lobster traps in the kitchen when he was suddenly called away to check on one of the nearby navigational aids. Not realizing that he had inadvertently left the tar that he was using next to the stove, Hawk could not understand why there was smoke pouring out of the beacon windows as he was returning. Thinking quickly, Hawk climbed to the roof and entered the tower. He found a quilt and covered the window to help eliminate the draft that was aggressively feeding the fire. He then proceeded to douse the flames with several buckets of seawater, ultimately extinguishing the mini inferno.

In December 1921, the steamship *J.C. Austin* developed a leak in its hull while underway just off of Pecks Ledge Light. Although the four crewmen who were on board were able to escape in a lifeboat, they had accidently left the oars behind in their rush to get off the sinking vessel. When the keeper, Charles Kenny, saw the men struggling to steer their little boat, he rowed his own boat through five-foot swells and helped the men to safety.

In 1933, Pecks Ledge received its new automated system, and in 1939, the original lens was removed. Today, Pecks Ledge Light still shares with Greens Ledge Light the duty of protecting the Norwalk Harbor.

3
THE NORWALK YACHT CLUB

A Foundation for Tradition

On August 6, 1894, a group of fifteen yachtsmen gathered for a meeting at the Canoe Club in South Norwalk. The purpose of the meeting was to discuss the details for a new boating association that they were in the process of establishing. The name of the association was to be the Norwalk Yacht Club, and it would be located at the water's edge on Hickory Bluff overlooking Wilson's Cove and Long Island Sound. Their intent was to

> *form an organization of gentlemen who are interested in boating and yachting, for the purpose of mutual acquaintance, amusement, enjoyment and social intercourse, and for the purpose of purchasing, holding, controlling and managing real estate and other property for the objects foresaid.*

That evening, Gilbert E. Bogart was elected as the new club's first commodore, and James C. Green was appointed as purser. Funds for the construction of the clubhouse were to be allocated through $10,000 in stock, with shares priced at $10 each. Within two weeks, more than $1,000 of stock had already been purchased. At that point, further officers of the club were elected, including Alfred E. Chasmar as vice-commodore, Charles Dimond as secretary and George A. Jennings, Horace S. Hatch, H. Emory Pease, Lewis H. Nash and William H. Byington as board members.

On August 22, 1894, another meeting was held to confirm that everyone was in agreement regarding the offer to purchase an acre of land at Hickory Bluff and to go over the initial plans for the design of the proposed clubhouse.

A week later, nine new members were inducted into the club, bringing the grand total to forty. On October 3 of that year, space for a temporary clubhouse was rented at the Washington Street Bridge in South Norwalk.

Upon finally signing the deed for the Hickory Bluff property, the club was bound to respect a few unique policies. These included "but one dwelling house shall be erected upon said premises…no spirituous or intoxicating liquor shall be sold, or kept for sale…no bowling alley, stables, horse sheds, or other nuisances shall be erected."

By the beginning of May 1895, the clubhouse was completed. On May 11, Emory Pease brought over the club's first float by launch, and on May 16, the Norwalk Yacht Club held its first official meeting at its new home. On May 30, members celebrated Commissioning Day for the club's long-awaited inaugural season.

With its elegant, three-story Victorian design set on an impressive stone foundation, the clubhouse quickly gained the attention of many area residents and soon became the center stage for local yachting.

On July 4 of that first year in operation as a formal yacht club, four members sailed on board George R. Van Alystyne's *Ward V* as they represented Norwalk at the Larchmont Yacht Club races in New York. On August 27 and 28, Commodore Bogart led the first club cruise on an excursion that would visit the port of Cold Spring Harbor, Long Island.

Co-founder and first commodore Gilbert E. Bogart was an active sailor, a reputable citizen and a man with "an appealing sense of humor." In 1895, Bogart helped to form the Yacht Racing Union of Long Island Sound. A passionate sportsman his entire life, Bogart reportedly broke a record in 1936 when he caught eleven bluefish weighing a total of seventy-two pounds, and he was eighty-two years old when he did it!

When Bogart passed away on February 21, 1956, at the age of 102, he had been a vibrant member of the Norwalk Yacht Club for 61 years. To date, no one has even come close to that milestone.

On February 29, 1896, Philip G. Sanford was elected as the new club commodore. For his first Commissioning Day in office on May 30, Sanford put on quite an event. It began with the raising of the flags to a thirteen-gun salute and a presentation by the commodore's wife of flower bouquets to the "wives and sweethearts of all the officers."

The afternoon featured a series of exciting races. The boats that participated included three canoe yawls, five St. Lawrence skiffs and two jib-and-main catboats. At the end of the day, Commodore Sanford surprised everyone with a fireworks display that the *Gazette* reported "lit the skies for

The Norwalk Yacht Club

far around, and enveloped the beautiful Clubhouse in a blazing coruscation of pyrotechnic glory." The gala concluded with dinner and dancing to the tantalizing sounds of the Philharmonic Band.

On September 7, the club held a Labor Day Regatta that, unfortunately, saw very little wind. The *Gazette* reported the race conditions as such: "The wind that had blown freely from the northwest shifted around to the southeast and died out...It was a long and tiresome sail."

And that it was, as the last sailor did not cross the finish line until more than eight hours after the first start gun had been fired.

The club soon proved to be a great setting for many social gatherings, as well as exciting cruising and racing opportunities. Twice a month the Ladies Whist Club of Norwalk would meet to play cards and visit, moonlight sails became very popular and evening dances became regular affairs. The club's fleet of vessels was growing larger every season with a variety of boats that included canoe yawls, cabin cats, open cats, sloops, knockabouts and dories.

A gentleman by the name of James A. Farrell was elected as commodore in 1903. Farrell was well liked by everyone and offered great leadership for the young club.

On January 16, 1911, the Norwalk Yacht Club hosted a "Chowder Party," the first midwinter event of its kind. The day was highlighted with music, singing, plenty of chowder and a boxing exhibition that was dedicated to former Commodore Farrell.

In 1912, another one of the club's original founders, William H. Byington, was voted in as the new commodore. That winter turned out to be one of the coldest ones in the history of Norwalk. According to an article in the *Hour*, the ice was thirty-four inches thick and cars could be driven across the harbor to the Norwalk Islands.

During a race from Norwalk to Manhasset Bay in June of that year, former commodore Dr. Charles Keeler was preparing for the start aboard his yacht, *Defiance*, when he noticed that Commodore Byington's vessel, *Flicker*, was experiencing a problem with its sails. Keeler chose to wait until Byington's boat was free of trouble before beginning the race, even though the gun had already gone off, and by all rights, he could have left *Flicker* behind. His example of good sportsmanship ultimately paid off, as he still managed to win the race.

The handicap system was introduced in 1912. It was created as a way of "granting a yacht a handicap of her losing margin in the preceding race." Seven races that summer would honor the new system.

In 1913, one race would find *Senora*, the vessel of William H. Farrell (the brother of former Commodore James Farrell), hard aground on Smith's

Island. After being stranded there for nearly an hour and a half, *Senora* was finally refloated with the assistance of the oyster schooner *Stanley H. Lowndes*. Since the other racers were experiencing rather light winds while he was aground, Farrell was able to rejoin the competition and, amazingly, crossed the finish line in first place, only to ultimately lose the race on corrected time.

One of the strongest membership years in the history of the club came about in 1914. During that year, Commodore Byington was a key player in the effort to try and convince the federal government to construct a breakwater for Norwalk Harbor. The proposal suggested that the breakwater run from Smith's Island along the natural reef to Greens Ledge Light. Although there was much support behind the plan, and many hours of hard work put toward getting it approved, the breakwater never came to be.

The Norwalk Yacht Club's pristine view quickly began to change with the United States' involvement in World War I. The railroad and shipping facilities located across the way from the club's spot on Hickory Bluff had typically entertained the great steamships of the Housatonic Railroad and the Iron Steamboat Company, such as the *Pegasus*, *Cape Charles*, *Cepheus*, *Cypress* and *Cereus*. Now, the dockside accommodations for these prominent ladies of the sea were replaced with a one-thousand-foot-long steel warehouse that was to be used for the emergency storage of naval supplies and wartime shipbuilding materials.

Even though the club was faced with a daily reminder of the war, regularly scheduled races and evenings of dining and dancing continued as usual, and updates like a new paint job for the clubhouse filled the off-season agenda.

In 1919, William H. Farrell took over the helm as new commodore. Farrell, at that time, owned an impressive yacht that boasted such imposing specifications as a 125-foot length overall; a 25-foot beam; a 14-foot, 7-inch draft; and 10,000 square feet of sail. It was, by far, the largest vessel ever owned by a Norwalk Yacht Club member up to that point. The vessel was named *Mystery* and was a steel auxiliary schooner built in 1905. Its designer was Cary, Smith & Ferris, and its builder was George Lawley & Sons out of Boston. *Mystery* was a stunning ship that was sadly lost in a fire on February 24, 1920, while docked at the Jacob's Brothers Shipyard in City Island, New York. The blaze, which reportedly started in a nearby frame building and then quickly spread to the docks, also claimed *Senora*, another of Farrell's yachts, and *Gem*, owned by William Zeigler of Darien.

The entire Farrell family were major contributors and great influences at the Norwalk Yacht Club from the early 1900s through the 1960s. Captain John Guy Farrell, an Irish-born ship owner, was the family patriarch and

was mysteriously lost at sea in the West Indies in 1874. During his career, Captain Farrell had sailed out of Fair Haven, Connecticut, aboard the brig *Monte Christi* and the schooner *Susan Scranton*.

His son, James A. Farrell Sr., originally brought his family to Rowayton and Bell Island during the early 1900s, when they would rent summer cottages for the season. Farrell eventually bought property at Hickory Bluff and built two houses; one was a Tudor-style home he called Rock Ledge. Unfortunately, not too long after Rock Ledge was completed, a fire broke out in the kitchen on the day of Farrell's daughter's wedding reception. On June 19, 1916, the house went up in flames, leaving only the four chimneys standing.

Not allowing the tragedy to get the best of him, Farrell rebuilt a new house, this time making it a grand mansion completely constructed out of stone.

William H. Farrell, the owner of *Mystery* and *Senora*, was an avid racer who won many trophies, including the 1914 Larchmont Yacht Club season trophy and the 1915 Norwalk Yacht Club Commodore's Cup. Two of his nephews, John J. Farrell and James A. Farrell Jr., were also active members of the Norwalk Yacht Club. John Farrell did much of his sailing aboard his sixty-foot motorsailer *Tusitala III*. James Farrell Jr. served on the club's board of governors, first as chairman of the budget committee and then as rear commodore in 1953 and 1954. James's personal fleet consisted of a fifty-six-foot auxiliary yawl named *Impala* and a sixty-two-foot powerboat called *Koala*.

Prohibition in the 1920s affected the shoreline along Rowayton and Norwalk. There were many bootleggers who used their boats to smuggle in alcohol at the point of Wilson Cove. As a matter of fact, one of the largest runs on record was stopped in 1926 at the Wilson Cove dock of the New York, New Haven and Hartford Railroad, directly across from the Norwalk Yacht Club. Over $100,000 worth of French liquors had been discovered stored in 1,480 cases of "alum" when a railroad agent happened to notice alcohol dripping from one of the railroad cars.

In the late 1920s, some new vitality was brought to the club when Charles H. Harris was elected commodore. Harris's innate enthusiasm for all things nautical and his unique way of looking beyond the horizon helped members William McHugh and Harold L. Nash with the decision to have their Star boat, *South Wind II*, shipped to Havana, Cuba, for the Third Annual Midwinter Series. There, they won a major victory for the club and the entire Central Long Island Sound Fleet.

In addition to encouraging members to look for sailing activities beyond Long Island Sound, Commodore Harris also sought to bring more motorboat action to the club. On May 30, 1928, the Norwalk Yacht Club hosted its first-ever outboard motorboat race. Even though a gangplank collapsed during the festivities, dropping twenty unsuspecting spectators into the harbor, the event was considered a great success.

Several hundred interested bystanders showed up to watch more than twenty boats in four classes compete on a four-mile course that ran from the club to buoys set off of Smith Island. Dinner and dancing later in the afternoon rounded out the festive event. The news report the following day described it as a

> *pretty scene along the waterfront, with flags and bunting whipping in the breeze at the Clubhouse; the scores of gaily bedecked yachts anchored offshore, with the large United States Revenue cutter in its grey colored paint in the background, steaming slowly back and forth.*

The editor of the paper appropriately called Commodore Harris a "live-wire leader" after his spare-no-costs production.

The race was a success again in 1929, but the 1930 affair turned out to be a bit of a washout. Heavy rain and gusty winds caused extremely choppy water conditions, ultimately contributing to an unfortunate collision during the second race.

In addition to his other accomplishments, Commodore Harris holds the honor of being the first to open up the club for use by the local Sea Scouts.

By 1931, the financial effects of the Depression were becoming more apparent. J. Henry Wehrle was voted in as the new commodore and chose to discontinue the annual motorboat races for the time being. In addition, membership dropped from ninety-three to seventy as yet another sign of hard economic times.

The first mention of Atlantic class one–design racing in Norwalk came after Norwalk Yacht Club member William J. McHugh placed favorably on his boat, *Mistral*, during the 1931 competitions held at the Pequot Yacht Club in Southport. This spurred an increase in popularity for the sport and a greater participation in one-design competitions in the years to follow.

As the Depression began to worsen, the members of the Norwalk Yacht Club became even more determined to carry on life as usual. Although money was dwindling, the energy of the club was growing. In 1934, Edward B. Gallaher was elected as commodore, with Lewis Wardell appointed as rear commodore.

The Norwalk Yacht Club

To keep members informed about the status of the club and its activities, Commodore Gallaher created the first of many newsletters that he titled the *Log*. Gallaher also put together the club's first annual yearbook, which included, among other information, the constitution, bylaws, a list of all elected officers since the inaugural season and a full directory of all of the yacht clubs from New York to Canada. Since club funds were low, Gallaher paid for the publications out of his own pocket. In addition, the commodore scheduled a series of weekly harbor races that summer. All of this helped to generate healthy club morale during a difficult time.

The summer of 1934 saw the first junior program implemented at the club. A gentleman by the name of Mr. Quintard ran the program that entertained fourteen junior sailors during its initial season. The cost was $100 per participant, and the program proved to be a great success.

In July, the club hosted the YRA of Long Island Sound Invitational Race, followed by the Syce Cup Series for women held in August.

With a thriving season behind them, both Commodore Gallaher and Rear Commodore Wardell were reelected, with Wardell now assuming the position of vice-commodore. Since the wheels were already in motion, Gallaher and Wardell decided to step up the pace. At one of the club meetings, the energetic commodore revealed his plan to lease an empty factory building in South Norwalk, where he would begin work on the development of at least fifteen Snipe-class sloops for the upcoming sailing season.

By 1935, more than twenty new Snipes had been built, and the club members were thoroughly enjoying their new fleet. The Snipe, at fifteen and a half feet, sailed best with a crew of two and was relatively inexpensive to put together and outfit. The first official team Snipe races were held on September 14 and 15, 1935. The racecourse was designed as a three-and-a-half-mile triangular route that began at the club, went to a buoy just past Greens Ledge Light, then to a buoy at the entrance of Five Mile River and, finally, back to the club. Seven teams competed for the trophy, with the Sea Cliff Snipe Club being the victor. The Norwalk Yacht Club entry placed fourth.

Snipe-class racing turned out to be yet another successful endeavor for the club and its forward-thinking commodore. Within a short amount of time, this new class of small-boat racing became a popular weekly event.

The mid-1930s also experienced a surge in powerboat interest. In 1936, forty members enjoyed a weekend cruise to Lloyd's Harbor aboard fifteen motor yachts. In July of that year, more than twenty-four sailing and powerboats, including the Snipe fleet, raced to Port Jefferson, Long Island.

In 1937, Commodore Gallaher announced the first annual cruising boat race to Duck Island. The club membership at that time was eighty-five, and an amazing eighty boats were moored in its waters—an admirable feat for the club officers!

Two pristine and rare steam launches graced the shoreline of Wilson Cove in 1939. One was an impressive sixty-two-footer named *Kestral*, and the other was a humble, yet stately, twenty-six-footer called *Rutherford*. Both boats were owned by Noroton resident and successful stockbroker James A. Trowbridge.

Kestral was an imposing vessel that was constructed in Charlestown, Massachusetts, at the Fore River Shipbuilding Yard under the design of George F. Lawley. A powerful fifty-horsepower steam engine turned the four-bladed propeller of this twenty-one-gross-ton vessel.

Commodore Gallaher was an avid and passionate yachtsman whose personal fleet consisted of a thirty-eight-foot auxiliary yawl named *Tamerlane* and a sixty-six-foot auxiliary schooner called *Flying Mist*. *Flying Mist* was built in 1917 by the Nevins Yard and was designed by Gielow-Orr. Many club board meetings were held on the magnificent yacht before Gallaher eventually donated it to the Junior Bluejackets of America in 1950.

Commodore Gallaher was recognized as a born leader. One of his seaside projects was the initiation of the "watchdogs for sabotage" program that encouraged local yachtsmen to do their share in protecting our coastline and the waters of Long Island Sound.

Gallaher served as commodore of the Norwalk Yacht Club for an unprecedented fourteen years. Many credit Gallaher with being the sole reason that the club survived the challenging years of the Great Depression. It was often said that if former Commodore Harris was a "live wire," then Commodore Gallaher was a "volcano."

In 1949, as the reins were once again handed over to a new generation, the membership at the club was at an all-time high with 116 active adult and 6 junior members. That same year, a third floor was added to the existing clubhouse to provide ample living quarters for the club captain (or steward).

In 1950, the junior program received a bit of a revamping as far as its sailing fleet was concerned. The board members opted to use Dyer Dhows for the younger sailors since there were plenty of them around the club that were being used as tenders, as well as in the Thursday night senior members races.

With membership on the rise, the club sought, and received, the approval needed to expand the mooring facilities.

The Norwalk Yacht Club

Sadly, during that time, the once popular Snipe fleet began to fall out of the picture due to newer, more advanced designs in sailboats that were arriving on the scene. After first being impressed with the Rhodes 18 as a possible replacement for the former Snipe one-design, the board ultimately decided on the nineteen-foot hard chine sloops known as Lightnings. The Lightnings were also picked as the boat of choice for the Junior Championships on Long Island Sound.

Over the next three years, Lightning sailing became all the rage for both junior and senior members alike. The race season began with a "practice" event in June that was then followed by a twelve-race Sunday schedule. (As a point of interest, although the Lightnings were a favorite among the members and used well into the 1970s, the Snipes still outnumbered them when they were at their peak during the 1930s.)

The commodore during this time was Ralph "Scapa Flow" Case. Case came from an oystering family; his father and grandfather were both oystermen based on the Five Mile River. Ralph Case himself had an eye for real estate development. From 1923 to 1924, Case invested in marshland in Rowayton, ultimately filling the wetlands with material that had been dredged from the river. He then listed the properties for sale, calling the newly developed area the Rowayton Beach Association.

After years of owning strictly working boats, Ralph Case decided to purchase his first actual cruising boat. The boat was a thirty-two-foot Alden cutter. Case's son recalls that new phase in his dad's yachting life, remembering it as a time when his family enjoyed "many new friends, delightful cruises, exciting races, and good fun."

In 1945, Case acquired his second cruising vessel, a forty-four-foot Casey yawl, which he named *Alcyone*. *Alcyone* sailed with its new owner twice in the Bermuda Race, winning first place in its division both times.

Upon returning to the club mooring field after the second Bermuda Race victory, Case and his crew were greeted with an enthusiastic reception of cheering members, multiple cannons and dipped ensigns. Case graciously circled the fleet, tipping his hat in gratitude and appreciation, and then inadvertently ran hard aground—a humbling moment after all of the accolades, no doubt.

Apparently, that was not to be Case's only humbling moment. His son, Ren, remembers one other such incident:

> On the occasion of another cruise, Commodore Case was leaving the anchorage under sail in a fresh breeze. Alcyone *sailed up on her anchor,*

which was raised smartly by her crew. Unfortunately said crew, in cutting the anchor, lost it overboard again, and as the boat tore through the water, about twenty fathoms of chain paid out. She abruptly fetched up, jibed, and headed off in another direction, scattering the fleet. A photograph shows the Commodore holding the award that he received for this maneuver. It may also have been this event that earned him the not-so-coveted Yellow Water Medal, awarded annually by the Cruising, Boozing and Snoozing Club (comprised mostly of Norwalk Yacht Club members).

Uninhibited by these unfortunate events, Commodore Case continued to sail *Alcyone* until 1957.

By 1951, the junior sailing program was beginning to grow, improve and expand at an impressive rate. That summer saw forty-three enthusiastic young sailors enrolled in the program at the club. A young man by the name of Ned Pierson was selected to run the quickly growing junior program. His resume was outstanding, with much experience sailing as crew on yachts to Bermuda, Nantucket and Annapolis. Pierson, a recent graduate of Princeton, had also successfully competed in a number of dinghy races for the Princeton Yacht Club and had extensive knowledge of the local cruising grounds around Norwalk. Under Pierson's guidance, the junior sailing program saw great success.

The big boat cruising fleet was also doing quite well at that time. In 1953, Gifford Pinchot sailed *Loki*, his thirty-eight-foot yawl, from Long Island Sound to Norway and England. There, he participated in the celebrated Fastnet Race and won a hard-earned silver medal.

In 1954, Pinchot, along with fellow members Charles Granville and Hobart Ford, competed and placed respectably in the Bermuda Race. In 1955, Gil Wyland and Ed Raymond placed second in the Manchester, Massachusetts–Halifax Race.

The club's annual cruise continued to experience a great turnout each season. The typically two-day event usually occurred during the July 4 holiday and would take its participants to a different interesting port along the shores of Long Island every year. One of the memorable voyages was the 1952 cruise, which took captains and their crew members to Cold Spring Harbor. There they were able to moor just off of the famous Roosevelt estate. On the way back, a festive picnic was set up on Sheffield Island, with launch service to and from the vessels cordially provided by the club.

The original clubhouse remained at Hickory Bluff until a proposal was made to move across the harbor to Wilson Point in the early 1960s. This new

The Norwalk Yacht Club

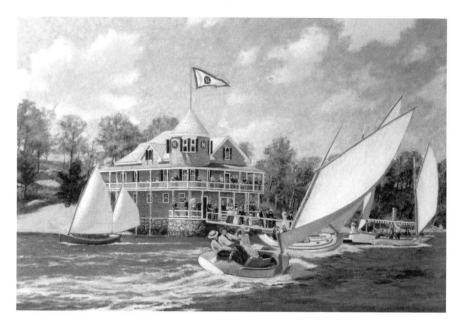

Sailing at the original site of the Norwalk Yacht Club on Hickory Bluff. *Courtesy of Clive Morrison.*

opportunity would allow for more ample parking and increased water depth for deeper-draft vessels, two issues that were unarguably ongoing problems at the Hickory Bluff site. Although some of the club members were initially against leaving their original clubhouse, it made sense from a financial and logistical standpoint. By the end of 1963, after successfully negotiating a deal for property on the other side of the harbor that would be more advantageous to the growth of the club, a new building was constructed. In the spring of 1964, members began their first full season at the new location.

The most recent site provided both the adequate parking space and deep-water accommodations that they were looking for. In keeping in step with the club founders' initial concept of a "simple" club atmosphere, the plans for an updated clubhouse reflected the idea that an environment with "no dining room; no bar; no slips for yachts" would be ideal.

The tradition that was set back in 1894 by a small group of passionate yachtsmen is still apparent more than one hundred years later. When you walk into the Norwalk Yacht Club today, the first impression is that of a quaint, relaxing and laid-back ambiance. As you meander around and begin to chat with some of the staff and club members, it becomes quite obvious that the Norwalk Yacht Club has been able to maintain the unique charm of yesteryear.

A History of the Rowayton Waterfront

As has been the case for over a century, the avid yachtsmen and yachtswomen who continue to make up the club membership come from varied backgrounds, with different opinions, attitudes and outlooks on life. Yet, with all of their dissimilarities, there is a common ground, one that was established long ago at this prestigious club. And although the years have dictated that the club adjust with the times, "the spirit, camaraderie and enthusiasm of members joined by their common love of sailing" has not changed. That quote comes directly from the opening statements of the club's *Centennial Book*, issued in 1994, and truly speaks from the hearts of its founding fathers.

4
ROTON POINT

"The Most Charming Watering Place on the Sound"

Located directly on prime real estate along the picturesque Norwalk shoreline, Roton Point has been an icon in the community going as far back as the 1800s. With Norwalk evolving as an independent settlement since the 1600s, the area now known as Rowayton was also slowly developing as a distinct neighborhood of its own within the town.

By 1868, nearby residents had begun traveling regularly via horse-drawn wagons in order to take advantage of the ideal picnicking and bathing conditions that were innate characteristics of this attractive waterfront location.

During the 1880s, the property at Roton Point was eventually leased to the Jacobs brothers, who were, at the time, well known as boxing promoters and publishers of *Ring Magazine*. With their vast experience in the entertainment business, the Jacob brothers saw an opportunity in their recently acquired land to create an amusement concession of sorts. Soon, people began venturing to Roton Point from miles around, including Long Island, New York City and up and down the Connecticut coast, just to spend a day at the newly created tourist attraction.

In 1928, a merry-go-round salesman by the name of Neville Bayley purchased the existing park as the Jacobs brothers had designed it and then immediately set the wheels in motion to turn it into an even more comprehensive and elaborate family entertainment facility. With Bayley's investment, it would grow to include a roller coaster, a number of carnival rides, boardwalk games, bowling alleys, weekly fireworks, beauty contests,

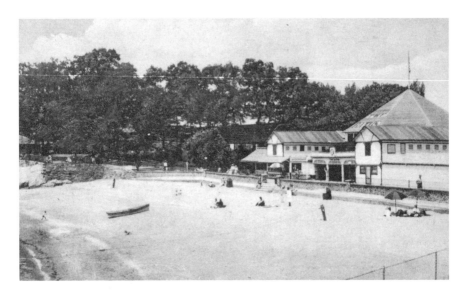

Roton Point Park. *Courtesy of Clive Morrison.*

West Beach at Roton Point. *Courtesy of Clive Morrison.*

big bands, dance competitions and dining for up to five hundred people at a time.

As the park grew and flourished, its reputation for being "the most charming watering place on the Sound" became far-reaching. Part of its

Roton Point

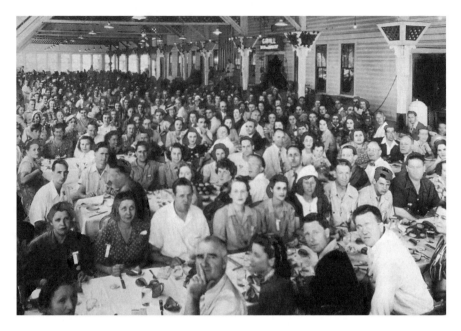

Dining on the porch at Roton Point. *Courtesy of the Roton Point Association.*

unarguable appeal was clearly due to the pristine location and unrivalled water views that characterized Roton Point. Other contributing factors were the amazing numbers of interesting and talented people who entertained the crowds year after year and the impressive schedule of events that became even more enticing each season.

Postcards were a popular item for visitors to fun-filled Roton Point. So much so, in fact, that writing stations were set up all around the park grounds to allow guests to be able to purchase, write, stamp and put their notes to friends and family in the mail all at once.

With the big band era in full swing, the park owners were quick to jump on the opportunity to entertain their guests with the best music available. An unmatched lineup of musical legends was presented weekly, and the musicians played for hours on end to the pure enjoyment of those lucky enough to dine and dance to their mesmerizing tunes. The extraordinary list included the likes of Glen Miller, Guy Lombardo, Benny Goodman, Louis Armstrong, the Dorsey brothers, Eddie Duchin, Bunny Berrigan, Wayne King, Cab Calloway and Duke Ellington, just to name a few.

The park booked other notable celebrities to impress its visitors, as well, like famed English Channel swimmer Gertrude "Trudy" Ederle. Ederle had

One of the many postcard greetings from the Roton Point Amusement Park. *Courtesy of the Roton Point Association.*

Postcards were popular items at the Roton Point Amusement Park. *Courtesy of the Roton Point Association.*

Roton Point

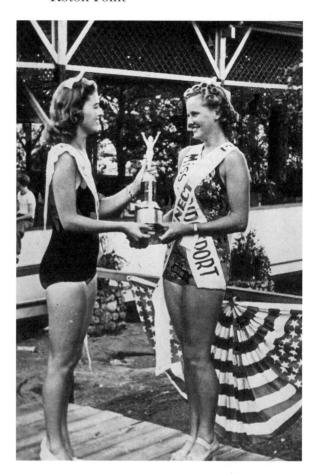

The Miss Connecticut Beauty Pageant was held annually at Roton Point. *Courtesy of the Roton Point Association.*

not only accomplished the amazing endurance feat that she was now famous for in record time, but she also did it two hours faster than any man had done it before.

There were also a variety of captivating events hosted by the park, such as a record-breaking speed car race that went down in the history books and an airship show that featured six of the most well-known airplanes of that time period, including the *Spirit of St. Louis* and the *Columbia*.

Of course, there was always the periodic scandal or two to keep things interesting around the park grounds. The Miss Connecticut Pageant of 1941 was one such scandal. Apparently, it ended in a huge outrage after it was discovered that the crowned winner was actually a married woman. Roton Point lost its privilege as host of the prestigious annual affair after that unfortunate occurrence.

A History of the Rowayton Waterfront

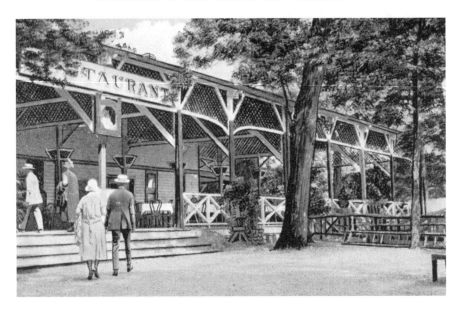

The restaurant entrance at the Roton Point Amusement Park. *Courtesy of the Roton Point Association.*

Aside from the celebrity allure that kept audiences constantly coming back for more, there also turned out to be quite a few local characters and incidents that drew broad attention. Take, for instance, the rags-to-riches story about the Casino Point Restaurant dishwasher who became a virtual overnight singing success when he was discovered entertaining the kitchen staff with his incredible tenor voice.

And then there is the account of two Roton Point Park speedboat operators who spent hours trying to convince the local police that they were not the bootleg rumrunners they had been mistaken for, just because they were making a bit too much ruckus while going for a night swim.

Or how about the unforgettable straitjacket escapade? A local paper announced:

> *The first public attempt to escape from a straight jacket while submerged in deep water will be made at 8 o'clock Tuesday evening at Roton Point Park as* [George Banfe of Bridgeport], *announcing himself as the successor to the late Houdini, ventures the feat to open a three-day engagement at the Norwalk resort.*

Roton Point

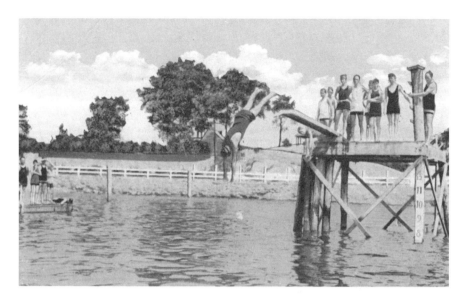

Diving at Roton Point. *Courtesy of Clive Morrison.*

Now here's an intriguing headline: "Roton Point Chef Bowled Over by Bolt of Lightning." It seems that the poor man was struck while carrying a tray of silverware through the hallway from the dining room to the kitchen.

Hot-air balloon shows were another popular draw, usually held during the annual Fourth of July festivities. Once the balloon was airborne, a stuntman wearing a parachute would appear from the basket and perform a series of acrobatics as he descended from the sky, amazing hundreds of onlookers as he tumbled and flipped his way back to earth. On one occasion, however, the parachutist missed his mark and landed smack dab in the middle of the mud flats. It has been noted that he was quite the sight with his red satin tights rolling about in the muck.

Although that particular parachutist must have been quite embarrassed about the mishap, he could not have been nearly as humiliated as the crew aboard the passenger ship *Crescent*. One summer evening, hundreds of park guests watched as the *Crescent* ran hard aground on Ballast Reef, just a little way down from the pier. Apparently, the grounding occurred as a direct result of the captain and crew sampling some confiscated liquor shortly before attempting to bring the vessel into port.

A History of the Rowayton Waterfront

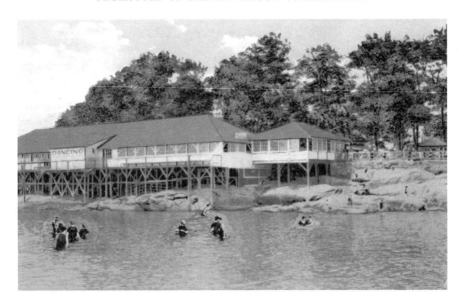

The Dancing Pavilion at Roton Point. *Courtesy of Clive Morrison.*

There is an admirable story about one of the bands that regularly played at the dancing pavilion. It was a father and son duo that hailed from Pound Ridge, New York. Without their own means of transportation to rely on, the two men would walk the twenty-five miles to and from the park carrying their instruments—a fiddle and a base violin—with them all the way, never once complaining about having to do so.

In those days, transportation for visitors back and forth to the park was as easy as hopping aboard a great steamship or paying the fare of five cents to ride one of the many trolley cars that continually dropped passengers at the fairground entrance every twenty minutes.

By the turn of the century, the number of guests visiting the grand amusement park was so great that there would be times when four steamer ships would be tied to the extended pier shore side, while five more were waiting patiently offshore for their turn at the dock. To understand just how many people were frequenting the resort on a daily basis, one must take into account that each passenger ship was well over one hundred feet long with multiple decks and had the capacity to carry twelve hundred commuters at a time. On average, ten boats would arrive throughout the afternoon and evening. That means that there was an influx of at least twelve thousand visitors that came to Roton Point by boat every day. Add to that the vast array of automobiles, trains and trolleys and the numbers get even more astounding.

Roton Point

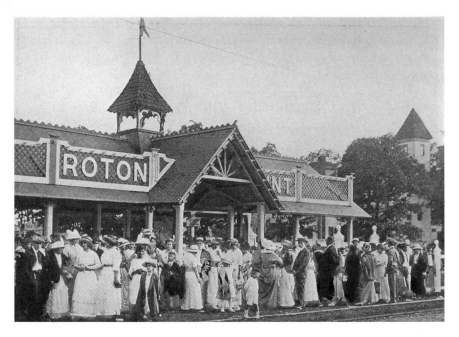

The Roton Point station, where passengers could catch a ride every twenty minutes. *Courtesy of the Roton Point Association.*

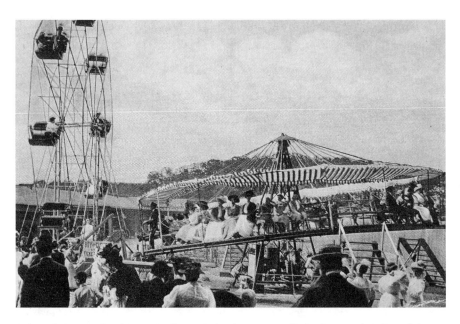

A few of the popular rides at the Roton Point Amusement Park. *Courtesy of the Roton Point Association.*

A History of the Rowayton Waterfront

In addition to hosting many rides, games and a variety of other carnival attractions, Roton Point was also very much a family setting that offered the opportunity to simply spend time and relax in the great outdoors. Church and fraternal groups, lodge outings, conventions, marching bands, chowder groups and Sunday school classes all were attracted to the beautiful grounds that made up the grove area of the park. At one time, there was even a "Society Circus" that was sponsored by the local Rowayton Reliance Hook and Ladder Company, which utilized the large shady lawn for an entire week. On any given summer afternoon, for any number of reasons, there could be found dozens of tables and hundreds of place settings underneath the trees.

As visitors strolled along the beach and midway, they would come upon all varieties of concession stands. There was a shooting gallery, a penny arcade, a "crazy house," a palm reader, a fortuneteller, a weight guesser, skee ball, games of chance and a number of food booths that served anything from hot dogs, ice cream and taffy to popcorn and cotton candy. One of the most popular booths turned out to be that of the glass blower. The expert craftsman would skillfully shape small pieces of glass into breathtaking objects right before the eyes of fascinated bystanders. As a matter of fact, many of the pieces are still treasured and proudly displayed at the homes

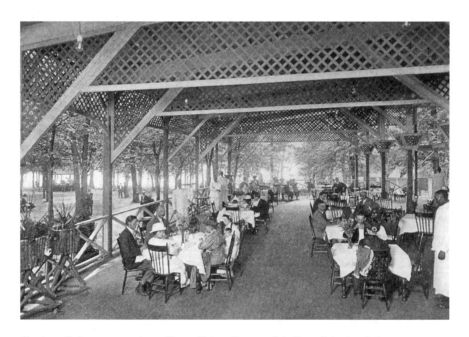

Outdoor dining was popular at Roton Point. *Courtesy of the Roton Point Association.*

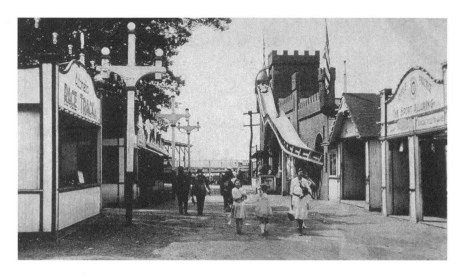

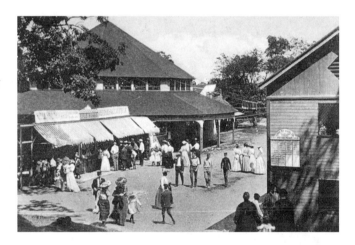

Above: The Midway at the Roton Point Amusement Park. *Courtesy of the Roton Point Association.*

Right: Booths and games of chance along the Midway at Roton Point. *Courtesy of the Roton Point Association.*

of current-day residents, as these souvenirs have been passed down through family generations.

The first roller coaster that was erected at Roton Point extended along the water at Bayley Beach. In the early 1930s, the original ride was eventually replaced by a shorter, but more adventurous, roller coaster experience. Other attractions included an automated circular swing, a carousel, an airplane ride, a "whip," bumper cars, a miniature steam train that circled the park, a vaudeville theatre, a fishpond and a skating rink.

The impeccable grounds surrounding the property were renowned for their incredibly beautiful plants and flowers. This, along with its perfect

A History of the Rowayton Waterfront

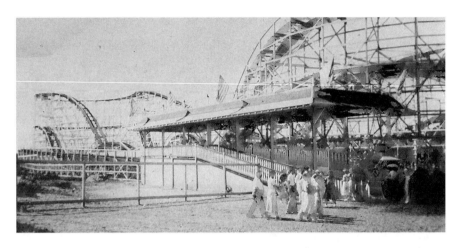

The second roller coaster built at Roton Point. *Courtesy of the Roton Point Association.*

The roller coaster on West Beach at Roton Point. *Courtesy of Clive Morrison.*

seaside location, helped Roton Point earn the reputation of being "the prettiest amusement park on the entire Sound."

Swimming and sunbathing were obviously very popular pastimes for guests at this pristine waterfront park. To accommodate the needs of the many beach goers, the park built more than four hundred bathhouses equipped with showers and lockers. If someone needed a bathing suit

Roton Point

to change into and had not brought her own, there was always the opportunity to rent one, along with bathing slippers, towels, beach chairs and even lifesaving "wings."

There was also a grand hotel on the Roton Point premises that was constantly filled to capacity. A casino, an indoor restaurant and a bar were all included in the design of this magnificent shore-side building, and guests were never at a loss for something entertaining to do.

The Roton Point Park continued to flourish in this fashion until 1938. That year, a powerful hurricane hit hard on the Connecticut coast. The devastation and damages caused by the storm were extensive. The park grounds were, for the most part, almost entirely ruined. With the effects of World War II becoming more intense, and with unavoidable changes such as fuel rationing and the loss of the excursion boats to overseas duty, the prospect of refurbishing the park to the condition it had been in before the storm hit looked even less promising.

Although this successful and lucrative seaside fairground would eventually be forced to close its doors forever, sadly bringing an end to one of the most magical eras in New England history, the property itself would ultimately recover and evolve into an active waterside and boating community.

Today, the 12.8 acres that make up the Roton Point property are home to the Roton Point Association, a private swimming, sailing and tennis

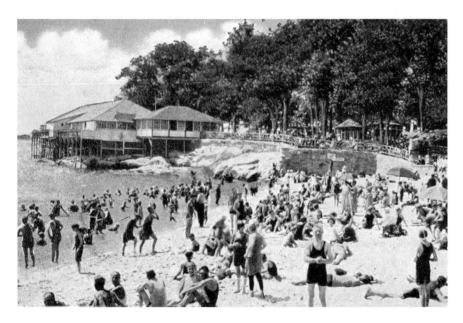

The beach at Roton Point. *Courtesy of the Roton Point Association.*

A History of the Rowayton Waterfront

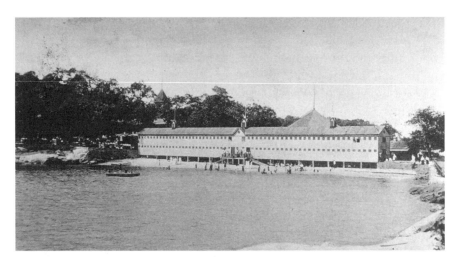

The bathhouses at Roton Point. *Courtesy of the Roton Point Association.*

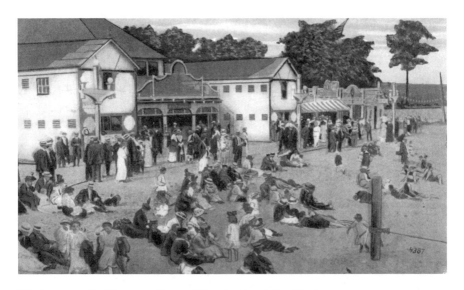

The beach and bathhouses at Roton Point. *Courtesy of Clive Morrison.*

club. Its facilities include a twenty-five-meter swimming pool, a separate diving and children's pool, eight tennis courts, storage and launch areas for small sailboats, a swimming beach, the original picnic grove area, a restored Victorian bathhouse with a fully stocked snack bar and the restored Victorian-era hotel, which is now used for a variety of social events

Roton Point

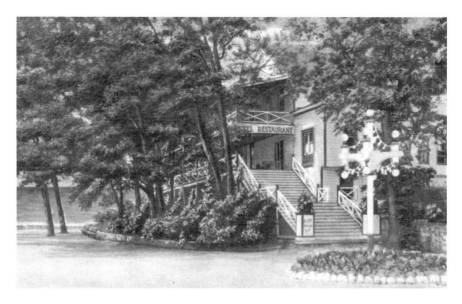

The entrance to the hotel at Roton Point. *Courtesy of Clive Morrison.*

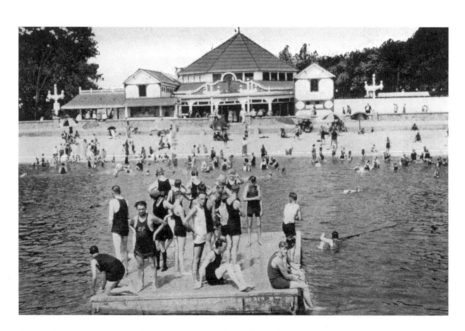

A busy beach at Roton Point. *Courtesy of the Roton Point Association.*

A History of the Rowayton Waterfront

A view of the water from Roton Point. *Courtesy of Clive Morrison.*

throughout the year. Every summer season, the current Roton Point Club hosts a busy schedule of swim meets, tennis tournaments, sailing regattas, dancing and live entertainment.

Although the dynamics have changed, Roton Point continues to offer breathtaking views, fun activities and many pleasurable memories to those who visit its historical grounds.

5
THE GREAT HURRICANE OF 1938
"The Long Island Express" Barrels across the Sound

On September 21, 1938, one of the most powerful storms in the history of Long Island Sound and the New England shoreline came through fast and furious. It was so intense, in fact, that the great hurricane of 1938 also earned the nickname "the Long Island Express" after it tore through coastal towns as if they were not even there. And some almost weren't by the time the devastating event was over.

As the storm made landfall, it was registering wind speeds of up to 160 miles per hour and dropping pellets of rain that were striking the ground like torpedoes. Even though Long Island typically acts as a protective buffer for the Connecticut shoreline from the direct effects of the Atlantic Ocean, the water surges coming from the sound were reaching heights never before seen in the state's history.

Joseph Kilbourn, a resident of Rowayton at the time the hurricane struck, remembers what it was like on that unforgettably stormy afternoon.

> *On what was up to then a dreary, windless day, my brother, three sisters and I piled into our 1936 Packard sedan at about 1:00 p.m. on September 21, 1938, and drove to the Palace Theatre in South Norwalk, where a double feature of* Dracula *and* Dr. Frankenstein's Monster *was playing. During the course of the second feature,* Dracula, *the picture kept dying because of the periodic outages of electricity. Finally, at about 3:30 p.m., we were told by the ushers that the movie was cancelled and that we, and the other patrons, had to leave. When we got out on the street we could*

see that there was a vicious storm in progress and that trees were down all over the place.

To return to Hickory Bluff, we had to take the back entrance to Wilson Point and drive down the driveway of Mr. Charles Dunn because of a tree stretched across Wilson Avenue where Ely Avenue intersects. We finally made it home about 4:00 p.m. at the height of the hurricane. Our house, which was adjacent to the Farrell estate, had a fine view from above of Wilson Cove and the Norwalk Yacht Club anchorage. The water resembled about ten feet of absorbent cotton, and boats were breaking their moorings and running down other boats. The Wilson Point shoreline where the present club is located was strewn with more than ten sailboats and yachts. As the eye of the hurricane passed over the eastern portion of Long Island, we had a brief respite, and then the storm, water and wind came out of the northeast with a vengeance. Many of the boats in the Norwalk Yacht Club anchorage that had survived the first onslaught broke anchor and ended up on the eastern portion of Bell Island. One beautiful miniature Bluenose schooner broke anchor and headed out into the open sound.

The storm went on into the evening as the autumnal tide continued to rise. Most of Rowayton Avenue and the south portion of Bell Island were under water. Finally, at about 10:00 p.m., the weather began to abate.

The following day, I visited the Yacht Club premises and talked with the steward, Captain George Moore, who rode out the storm on the third floor of the clubhouse with his wife and son, Don, who was a club launch boy. Captain Moore told me that, at the height of the storm, he felt the club building rise up slightly and opined that if the tide had risen another six inches, the clubhouse would have floated into the anchorage.

The shoreline of Wilson Cove was a scene of devastation, with boats, pilings and other debris spread out all over the area. In particular, the Thomas School, which lost the front end of its boathouse, and the Hickory Bluff Store suffered severe damage, with the latter losing one whole tier of bathhouses. Other than the water damage on the ground floor and damage to a portion of the dock, the Yacht Club survived rather handily. It was not until the following spring, however, that the area was finally cleaned up.

The hurricane damage was extensive. Giant trees were ripped out of the ground, power lines were down all over town, sidewalks were torn up from the roots of toppled trees and boats of all shapes and sizes were either swamped, severely damaged or, in some instances, completely smashed to pieces. Storm surges caused water levels to rise at least seventeen feet above

The Great Hurricane of 1938

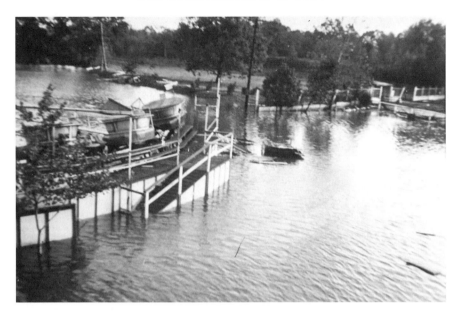

Damage from the Great Hurricane of 1938. *Courtesy of the Roton Point Association.*

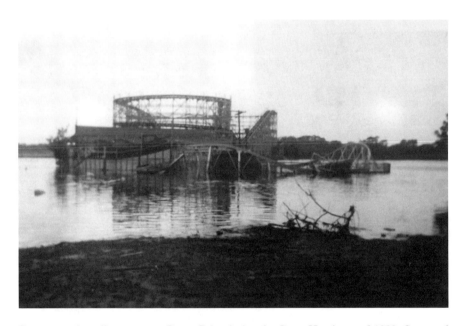

Damage to the roller coaster at Roton Point during the Great Hurricane of 1938. *Courtesy of the Roton Point Association.*

normal. Tidal waves of fifteen to thirty feet ravaged the shoreline. Bridges and roadways were impassable. It was days before the railroad systems were able to operate on a regular schedule. The Silvermine, Norwalk and Five Mile Rivers were foaming ferociously as they flooded over their banks. When the storm had finally passed and the tides began to return to normal levels, the rivers remained completely out of control.

Roton Point Park suffered the loss of almost all of its rides, including the popular beach-side roller coaster. The dock and pier were nearly destroyed, and some say it's a miracle that the hotel was still standing at all. At Calf Pasture Beach in East Norwalk, the buildings and walkways were completely washed away by the pounding surf. More than two hundred bathhouses were seen almost a quarter mile from their original spots. Broken windows, flooded basements and remnants of what were once roofs were seen in abundance when walking through town and surveying the local homes. An incredible amount of lumber from the town lumberyard was distributed around the community like sticks of straw or found floating in the river like twigs. Even the oyster beds that sat at the bottom of the water were affected; they were relocated by the strong action of the waves to different parts of Long Island Sound. Some of them were moved so far away, in fact, that the oyster bed owners never recovered them.

To date, the Great Hurricane of 1938 remains in the Connecticut history books as the worst natural disaster to ever hit the Nutmeg State.

6

HICKORY BLUFF AND THE ROWAYTON YACHT CLUB

An Era Remembered

The current-day Rowayton Yacht Club is located on a beautiful piece of property at the entrance to Bell Island. With a front-row seat to fabulous views of Long Island Sound, the Rowayton Yacht Club has retained the humble atmosphere that has been a part of the allure of the area for centuries.

Prior to hosting a yacht club, the property was home to a small bait and tackle shop, as well as the old Hickory Bluff Store. There are still some residents who can remember the early days when the store, the beach, the boats, swimming, tennis, fishing and just hanging out at the "Bluff" were what made Bell Island so special.

One such resident was a gentleman by the name of Bob de Courcy. Former Rowayton Yacht Club commodore Clive Morrison had the opportunity to catch up with de Courcy many years ago, and the following are some of the memories de Courcy shared about his time spent growing up during the early to mid-1900s along Hickory Bluff and Bell Island.

> *At that time, there were few automobiles, the trolley ran to Roton Point in the summer months with a stop just a block from the Bluff and there were few public beach facilities. Bathhouses rented for twelve to fifteen dollars for the season, never by the day. There was always a waiting list. Canoes were much in fashion then. We had a rental fleet of a dozen or more and just a couple of rowboats.*

A History of the Rowayton Waterfront

In the later 1920s, automobiles were more available. As Calf Pasture in Norwalk and Pear Tree Point in Darien were developed as town beaches, the emphasis shifted more to boats. It was about this time that outboard motors came along. It was also when I started to work [at the store]. *We were agents for Johnson Motors; didn't sell very many but did start renting them.*

In the Depression years, boat rentals kept increasing in importance. We had twenty or more rowboats. On weekends, everyone would be out by 8:30 a.m., especially when the tide was low. Clamming was big; people were easing the food budget. We did not rent moorings but started, very slowly, to give dock privileges. This part of the business gradually grew.

Working at the Bluff seemed to attract adventurous and fun-loving young people. There's nothing like just messing around in boats.

I started to work there in about 1928 and continued until 1938—longer than anyone who didn't own it—and was the last one to live and sleep there. You see, George [Schlichting, the owner] *had converted a couple of bathhouses on the parking lot side of the store building into a bunkroom and elementary kitchen, i.e. sink, table and hot plate. That was his summer home until 1929. The idea was to have someone around in case of fire or vandals, both of which we did have. In fact, one night in 1931, we had both thieves and a fire the same night!*

It was a midsummer night with high tide just after dark. People had been swimming until a sudden shower sent them home. I woke in the night to the normal silence and normal light sounds, the "Quauk" of a night heron, the shifting of the boats at the dock as the dying ripples from a passing tug reached us. But then I sensed a foreign sound. Someone was pumping gasoline. In those days, we had a gas pump, hand operated of course. We didn't lock it. We simply removed the handle as we closed up. So, in my pajamas, or whatever I slept in, and bare feet, but with a loaded .410 shotgun in my hands, I silently picked my way to the front windows. Sure enough, by using a pipe wrench, they could turn the shaft and steal gas. Now these were the days of prohibition, bootleggers and gangsters. In spite of the .410 in my hands, I hesitated to accost the thieves. After all, they could have been hardened felons who couldn't risk being seen at an open gas station and who wouldn't hesitate to mow me down in a hail of bullets. So, they drove away, and I caught all but the last number of their license plus a good description of the car. The police rounded them up the next day—not gangsters but local kids who had been stealing at other places.

Later that same night, I woke and heard a loud, not crackling, but an intermittent snap like a small firecracker. Then I smelled smoke. Some late

Hickory Bluff and the Rowayton Yacht Club

swimmers had left a candle burning. It was on the back wall of the back row on the dock. Fortunately, the shower that sent them home in a hurry had moistened the wood a little. A few minutes more would have been disastrous. It had just burst into flame when I sprayed it with one of the Pyrene extinguishers from the outboard motors. But it was still smoking a little and had burned in behind a two-by-four. By now I was a little unnerved and went in and called the fire department, explained that the fire was out but they should check it and that they should not wake the neighbors with sirens and lights. We were theoretically out of the fire district. But they were nice enough to come anyway and drove slowly down the street with siren blowing and spotlights sweeping every house!

One night, I woke to the soft splashing sound of swimmers. I looked out the window. Two girls were skinny-dipping. Two piles of clothes were on the porch just outside the window. My hand was on the light switch, but it never moved! I didn't make a sound or hear a sound, but maybe did, because all of a sudden, they rushed up the beach, jumped up on the wall, snatched up their clothes, jumped into their car and instantly drove away.

Henry Maury revived canoe sailing. Not surprising as the Maurys are descended from Mathew Fontaine Maury, who charted the ocean currents. In 1926 or '27, Henry had been sailing in Bermuda. When he returned, he dug out leeboards and lateen sails for canoes. For a number of years, we did a lot of sailing in canoes. It was exciting, not only because canoes are tippy, but also because, as the canoe heels, the leeboards tend to scoop water into the canoe.

We kids would see some project that we thought would be an improvement and would propose it. George was a taciturn person. Our answer was usually blank silence. Then, very often, some morning, the project would mysteriously be completed, apparently by midnight Leprechauns.

The biggest of our projects was turning over the float. About the nastiest job of the year was applying copper paint to the bottom of the float. It had to be brought in on the beach and allowed to rest on blocks so we could crawl under and paint the underside of the pontoons. Anyone can imagine how much easier it would be to have it lying bottom-up. We could just stand up, like painting a floor, no dripping down your arms or on your feet. We spent nights calculating the buoyancy, positive or negative, of every board and bolt. Then we attached pieces of trolley track to neutralize the buoyancy to perfect equilibrium and towed the float out to deep water. It worked! But remember, this is at night. A tug came in the channel, nearly ran us down and made waves. But at dawn, there was the float, lying

A History of the Rowayton Waterfront

Bathing at Hickory Bluff. *Courtesy of Clive Morrison.*

on the beach bottom-up in the sun. It was the best paint job ever. In the evening, just before dark, we proudly and confidently towed her out to roll her back. It went smoothly until, when she rolled over and came right side up, she rose, like Moby Dick, under our boat, neatly lifted our outboard motor off the stem and dropped it into eighteen feet of water. My reflexes aren't usually quick, but this time, before that motor was out of sight, I had one of the pieces of trolley track (with a rope on it) following the motor to the bottom. Realize that there were no metal detectors in those days, and even the words "snorkel" and "scuba" hadn't been invented.

Bud Lynch was the best swimmer and diver around. He was then working at the Tokeneke club. But by this time it was dark, and someone found and brought him to the rescue. He pulled himself down my rope, found the motor and attached a grapple. I could finally go ashore (would never had dared to appear without that motor). A submerged motor must be cleaned immediately. So I went to work, first draining the gas tank (tanks were part of the motor then). The gas looked clean to me, and not wanting to waste it, I poured it into George's car. It turned out that there was water in it. He was about two miles toward home when he stalled. We never turned over the float again.

The bar that lies on the Bell Island side of the beach was a dense mussel bar. After the Norwalk sewage plant was installed, there was a great die-off.

Hickory Bluff and the Rowayton Yacht Club

Anyway, with the mussels mostly gone, we found that area to be strewn with arrow points. At any good low tide, one could pick up a dozen or so. The best theory was that Indians had been shooting ducks there for many years. Or maybe in pre-Columbian times that was dry land, the site of an Indian village.

It was sometime after 1934 that the landing float was made. Before then we had to go down steps to load a boat. Winter flounders began to run in April. You could catch a good mess almost anywhere.

Opening day for the store was traditionally Memorial Day. We would have just a couple of boats in the water in April and launch most of them during May. Blackfish came when the dogwood bloomed. Sometimes there would be a run of porgies. That would liven up the summer months. In August, the small snapper blues would start and would reach fair size by Labor Day. Occasionally, some exotic fish would be around for a while. One year, a school of sergeant majors hung around for several weeks.

The season used to end with Labor Day. But as fishing and boating grew in importance, the season lengthened to Columbus Day and beyond. Autumn is lovely at the shore, and the fishing is the best then. Flounders pick up, blackfish run well, especially on the offshore reefs, and the snappers get to be really good sized. Sometimes there would be a run of tinker mackerel or even frostfish. I believe that there were big blues around in those days. But few people were equipped to find them. Once in a while, it would be big news that someone had "run into" a school of blues. It was usually early morning. The blues were feeding on the surface, and one could get a few before they went down deep. One time, George McKendry and I were returning from a cruise in his open sailboat and found ourselves in a school of blues. We tossed over a feather jig on a hand line and caught two seven pounders. But we had no power and couldn't follow them upwind. Today, if the gulls are diving in the middle of the sound, there will be ten high-speed boats clustered around in minutes, all equipped with fish finders, downriggers and 150 horsepower motors.

My uncles told me about striped bass. You troll a spinner and worm among the outer rocks at dusk, just before high tide. I did it. I did it for years! If I had worked those hours at even a dollar each and saved it, I could have bought Bell Island. Once in the mid-'30s, three men rented a boat and returned with a twenty-five-pound striper, caught off "Yellow Rocks" on the outside of Sheffield Island. Maybe they knew what they were doing. Maybe it was just dumb luck. Anyway, it was the first one I ever saw. In 1937, I caught my first one, trolling off Fish Island. From then on, they ran well for about forty years.

A History of the Rowayton Waterfront

Bait was always a problem and a "big deal." You could use ordinary garden worms for flounders. Fiddler crabs were the bait for blacks. We sometimes caught them at low tide in the marshes in Ram Island Bay. They sold for a dollar a quart but were worth ten times that! We did not regularly sell them, but sometimes we would get them for a customer. But then we became pioneers in a new industry: importing fiddlers from Florida.

In those days, one could find fiddlers by the millions along any sandy beach road in Florida. You could herd them onto a sheet and pick up a bushel at a time. George had spent winters in Florida, where he made a deal with a local cracker to try shipping them in bushel baskets. There were problems—no airfreight, two or three days by rail. When crabs die, they decay immediately! It's a long story. But it worked, we became a dependable source, and after a few years, the New York area bait stores were selling "Chinabacks," so-called because the Florida crabs were not black like ours but were cream colored with red and blue markings. Then we also started importing sand- and bloodworms from Maine. They are universal bait for all saltwater fish and always better than garden worms. But we were not pioneers, as that had been an established business.

The biggest activity was in snapper bait (spearing or shiners). We never could get enough. As the season progressed, we went out every day. We dragged a thirty-foot seine, tried to find a reasonably smooth place that wouldn't cut up the net or our feet. A favorite spot was a little sandy spot just north of Corby's dock, a little south of the entrance to Ram Island Bay. The technique was to chum with sardines until we had a school gathered and then try to drag around them. We had a number of good spots and had to hunt for our quarry. We also went at night and dragged the beaches; the bait came in to feed and also to avoid predators. This was often quite productive. But working in the dark also posed problems like getting into jellyfish and other junk. We also caught other species that we had to sort out. This was before the days of frozen foods, but we developed a system of freezing bait. We dipped them in brine, put them in ice cream containers and froze them in the ice cream storage—not as good as fresh but satisfactorily usable.

Sand sharks (dogfish, Squalus acanthius*) often seemed to bite while one was fishing for something else. The bottom seemed to be paved with them. Many were two feet or more long. Nobody wanted them. Now they are regularly in the market. In biology class, studying their cranial nerves, I had the brilliant idea of earning a semester's tuition supplying heads for the laboratory. Hamilton College agreed to buy a hundred for a dollar each. Wow! Fishing for fun and profit! At first, we went out in a big rowboat,*

Hickory Bluff and the Rowayton Yacht Club

five or six fishermen. The Leo family (five boys and a baby sister) from Bronxville were on Bell Island. Their boat had a covered cockpit, a head, even lights and held ten or twelve fishermen. We started using it. You drift, because when caught, sharks immediately swim in a circle, which would include the anchor line. Those fish, which seemed so prevalent, turned scarce. One in a four-hour expedition was a record catch. But even one big shark circling ten lines in the dark was real excitement. Bud Lynch, then a medical student, was aboard one successful night. After carefully removing the head, he then dissected the body, removing and explaining every organ. At the end of two summers, we had about twenty-five heads. The college suggested that Wood's Hole was a more reliable source. It was a commercial failure but a social and educational triumph and is remembered to this day.

It seems to me that the biomass in the water was greater then. On any high tide, even in the daytime, one could drop a bait trap over on the bridge side of the bathhouses and, in a short time, have a good pile of "Killys" or "Mummies." Right on our beach, I have drawn the seine around one school of baby bunkers (menhaden) and filled a full bushel tub. They were no good for bait because they turned soft, but you could use them for chum.

Our boats were all plain flat-bottomed rowboats, ten to sixteen feet long. As motors came into use, we built a couple with little shear and wide, flat stems. They were stable and worked well with motors; they certainly didn't plane but sort of slid along. In time, we did acquire several modern outboard motors—more later. The first Johnson motors were four horsepower, two opposed cylinder (cast iron)—they fired simultaneously. They had no underwater exhaust, no reverse (you turned the motor around), no idle (when the motor started, the boat started), no outside fuel tank and, of course, no electric start or remote control. The aluminum gas tank was bolted directly to the cylinders. The muffler was a can mounted below it. Can you imagine how many gallons of gasoline we spilled overboard trying to reach out and pour into those tanks or what happened when that gas spilled down on the hot muffler? That was called the "light twin." Then there came the eight-horsepower "standard twin" and, eventually, the sixteen-horsepower "big twin." They were practically identical except for size.

Starting the four horsepower was not bad, but the big ones provided some thrills. You crank with a rope, brace yourself and pull. But if the spark is a little advanced, the motor kicks and spins around. I still bear the scar from the time I stood a little too close and the steering handle cut to the bone just below my left knee. The next one is when Murphy's law is suspended and the beast starts on the first pull. Sixteen horses pull

the rug from under you, and you are lucky if you stay in the boat. Until my dying day, I will remember the moment when I held the boat for an inexperienced boater (it was before we had a landing float). The motor started. He lost his balance, grabbed the tiller and careened off toward the swimming float. He over-corrected and passed right over a swimmer in the water. I watched in horror! But the swimmer reacted, did a surface dive and ended up with a gash on his buttock—serious enough, but it could have been his head.

We had four modern outboard boats—all wooden, naturally. One was a varnished mahogany smaller replica of the beautiful old Gar Wood or Chris Craft speedboats, made by Laconia [New Hampshire] Car & Foundry. They built trolley cars and had turned to boats because trolleys had become obsolete. At the time, we never appreciated the fine craftsmanship. Today, that boat would be a treasured museum piece.

While most of our canoes were Old Town, we were also dealers for Kennebec, who were expanding into this new market, and we had one of theirs. It showed the skill of the canoe builders, smooth sided, planked with thin cedar, round bottomed, also round chined and, fortunately, with high freeboard; in a tight turn, she was almost sailing on her side. It was a good craft but was too delicate for rental service.

The other two were a thirteen- and a fifteen-foot clinker-built [lapstrake] by Lyman from Sandusky, Ohio. They were good boats, we made, and with a shape that would still be right today. We generally used those for our bait gathering.

With the sixteen-horse big twin, any of these could cross to Sheffield Island in three minutes, a speed of about twenty knots.

Most of our rentals were the four horse, occasionally the eight. They were pretty crude compared to today's motors. When a customer came rowing angrily home with a dead motor, it was our policy to refund his money if we couldn't start the motor in three pulls. Most of the time, we could. That made him even angrier. But we really did try to be understanding, generous and sympathetic.

The history of immigrants living on the islands goes back 250 years to the first settlers. But in my time, Mr. Wickenhauser owned Tavern, Mr. Corby owned the north part of Sheffield, Cap'n Stabell owned the lighthouse and vicinity and lived there in the summer, the Cavenaughs had a substantial house south of Stabell's and there were several houses on L. Hammock in Ram Island Bay. Except for picnics, camping and, in the fall, duck hunting on Ram and Copp's, we didn't have much contact with the others.

Hickory Bluff and the Rowayton Yacht Club

Tavern Island owned the land next to the Bluff. The stone wall with its high chain-link fence and especially the dock and float assembly are quite a piece of work and apparently have been there for a long time. They had a clinker-built launch, run by the caretaker, Ed Macphail. Having their own dock, they were independent. But we knew them and had good relations with them. Tavern had city water and electricity and probably telephone. *We frequently dragged for snapper bait at Little Tavern and the bars* [sand] *around it.* The Wickenhausers moved, apparently back to Germany, in the middle '30s.

Mr. Corby had two boats. Rebel, *named after his then wife, was twenty-five to thirty feet, with a large covered and comfortable cockpit, very little cabin space below; what there was was filled with a six-cylinder engine about six feet long and about as tall—no little compact high-speed driving through reduction gears in those days! She was a model called "Play Boat," boat and motor made by Consolidated Shipbuilding plant down on the Harlem River. It was wooden, of course, a modern design with a hard chine and flat stem, and could jump up to a plane and fly over to the landing in about two minutes with that massive engine hardly turning over!* Betty B, *named for a daughter, was a workboat, a good-looking lapstrake with a big open cockpit, just a little covered space forward.*

Captain Thursten O. "Tut" Stabell *was the Corbys' captain. The Corbys used the Tavern Island landing. But Tut, and other islanders, used ours. Tut had a double-ended open blue boat. Maybe you would call it a whaleboat, steered with a tiller, powered by a classic old Palmer "make and break" one-lunger, started by grabbing the flywheel and flipping it back against compression, no starter, no reverse, no clutch. To stop, you pulled off the ignition and coasted to your landing. I can still see him at dusk on a Sunday evening returning his family and friends after a day on the island as he came putt putting around Bell Island and then slid to a perfect stop beside our steps.*

Rebel *used a lot of gas. Occasionally we fueled her. Tut would bring her alongside our dock at high tide to avoid using the steps. We pumped the gas* [by hand] *at the front of the store into two ten-gallon cans. It's easier to carry two at a time; they balance. The funnel on the boat was a large cylinder with a spout, a pipe that extended into the tank. We handed the can to Tut, who poured it. He always had a lighted cigarette in his mouth. When I questioned this practice, he explained that it took a "live" spark to ignite the gas. He obviously had never studied the phase rule or about the range of combustible mixtures. But he did demonstrate, by flipping his*

lighted butt into the liquid, that it would be extinguished. I never tried it; I had studied about those ranges.

The Depression deepened. Eric Will was now the caretaker. He probably was not being paid. He tried raising chickens in the barns. The endemic rats, with a food supply, became epidemic. We used to row over and shoot them, but I doubt that we even made a dent. By 1934, everything was neglected. But the gardens still bloomed and were beautiful. I would go over and return with armfuls of hyacinths.

We were occasionally asked to take guests to the islands. Since we were not licensed to carry passengers, this was an informal arrangement and was a pleasant duty. It was fun to meet new people, and we liked to show off a little. Knowing the currents and the bottom contours, we knew where the waves were rolling and liked to show how skillfully and smoothly we could guide the boat. We knew ranges and courses to any of the buoys in the harbor, even in the dark. So another trick, if the guest were facing aft, was to have him suddenly see a big black can about a foot from his face.

Mr. Corby died in 1937. At about that time, some of his daughter's friends, the Millers, were there. It was a low-key arrangement with paying guests who seemed to be friends. Mrs. Miller stayed on the island. Mr. Miller worked in New York and came up weekends. He was the son of Alice Ouer Miller, a well-known author. I had indirect connections with them through college and used to sail over occasionally to talk with Mrs. Miller's sister.

This venture continued through 1938, when Mrs. Miller was alone on the island through the hurricane. It must have been a terrifying time. But she came through unharmed. I never saw any of them again. The place was wrecked and, in spite of occasional attempts at restoration, has gone downhill until now nothing is left but the stone pier from the landing. But the present use as a preserve is probably a higher and better use.

A decade ago, when someone sent me a clipping with a headline—"We want to keep it just the way it is"—I burst out laughing. In my day, it was my impression that the neighbors would like to bulldoze the whole place right out to sea! Actually, most of the time we got along pretty well.

Mrs. Waters lived in the house next to the store. We always considered her an old busybody because she occasionally complained about noise at night. It occurs to me now that I never actually saw her or spoke to her. In truth, she was probably a sweet and lovely elderly lady—and no older than I am now. Next was a family named Rush. My recollection is that across the street they had a tennis court, which, before my time, George leased and

Hickory Bluff and the Rowayton Yacht Club

The roadway leading from Roton Point. *Courtesy of Clive Morrison.*

rented to his customers. Their son was a dentist who was one of George's hunting companions.

Across the street, facing Sammis Street, were the Pierings, and across from the store, their daughter and son-in-law, the Mounts. He worked in New York and liked to tell us how things were going on "the Street." Maybe we should have listened. We were all generally friendly, although sometimes on a busy weekend, Mrs. Mount would call the police to complain about parking.

The McKendrys, from New Canaan, lived in the house nearest the bridge; three children, George F. (whom we called Fran), Millicent and Marilyn. Mr. McKendry was the person who later arranged the purchase of Roton Point. Fran had a boat—open, about twenty feet long, flat-bottomed, high straight sides, built by a carpenter and looked it—that nevertheless could sail like a champion. We sailed on it many evenings. We took it on cruises, rigging a tarp over the boom for shelter and sleeping beside the centerboard trunk. Fran was one of those rare natural helmsmen who could make a boat move in the slightest of breezes and who could make it point higher into the wind than it ought to. When the yacht club built the Snipe fleet in 1935, he was a star skipper and taught many of the newer ones. That year marked the end of canoe sailing, and we moved into Snipes and others. And it was the year that the Bluff crew went to the trouble of crating a canoe to ship

to Utica, New York, so that my roommate and I could sail it home. I doubt that I ever thanked them enough.

The McKendry house, being the geographical center, was the gathering place for "the gang." Others were the Harts' house (the stone "castle," which burned some years ago) and the store itself. The McKendrys eventually bought a house on the hill on Bell Island.

The old Bell Island Bridge was a massive wooden structure, was more fun to fish from and always a popular spot during snapper season. It had a sign: "Load Limit 6 Tons." When the driver of an eight-ton steamroller approached it one day, he practiced safety first and stepped off before the bridge. The roller behaved and went safely across in a perfectly straight line. But on the Bell Island side, the road pitched down at a steep angle. The roller speeded up. It veered to the right. The wooden guardrail was no match for sixteen thousand pounds of rolling metal. The "crick mud" back there is about five feet deep. Without today's big cranes and tow trucks, the removal was the show of the week.

Hugo Kerner was a German waterman, had spent a lot of time in the boatyards at City Island, knew the sound from Greenport to Stepping Stones, had some connection with the Stabells and moored a boat off the Bluff. He used our dock and let us use his boat. It was thirty-eight feet long, ten or twelve wide, had very little sheer, looked much like the dual-centerboard racing scows used on the Wisconsin lakes. It once had a centerboard but now had a fin keel six feet deep, gaff rigged with a long boom reaching six feet or so beyond the stem, and a bowsprit. (Keep that bowsprit in mind for later.) On a reach in a fresh breeze, she could really fly, was practically on a plane. She had a big open cockpit with seats all around and just a tiny cuddy cabin forward. We even sailed her once at Christmas vacation. Nobody had any money then, but we would repay Hugo occasionally by chipping together ten dollars or so to buy a new halyard or other needed replacement.

One evening, a bunch of us, including several of the younger kids, started off in a nice brisk southerly. In spite of the six-foot draft, we regularly passed close to the end of Tavern, inside Half Acre Rock ("fool's rush in"). We sailed out the eastern passage, booming along the coast, past Penfield and into Southport to look at their fleet of Atlantics (there was only one at our yacht club). It was still light when we started toward home. But you know what those fresh evening southerlies do. It not only slacked but also shifted west as the tide ebbed against us. Hugo's boat flew on a reach but did not beat, especially into a ground swell. You get the picture! When we

Hickory Bluff and the Rowayton Yacht Club

finally arrived home at about 1:00 a.m., every parent in the neighborhood was there to greet us. I had been the captain on that trip. My approval rating slipped to an all-time low. My honorary title of "Uncle Bob" was withdrawn for a year.

On another evening where I did not participate (the store stayed open till nine in summer), some of the gang were returning from an evening sail and maneuvering through the anchored boats toward the mooring. Remember that none of our boats had any power; you sailed from your mooring and sailed back to it. And if you missed, you went around and tried again. Somehow they found themselves about to crash straight amidships into Irving Jenning's Rozzy J. Some quick person jumped aboard and raised the bowsprit just enough to miss the topsides and only smashed the combing. A horrible moment. Of course, with trembling hearts, they immediately reported the damage. But, as far as I know, we never had to pay for that. Mr. Jennings must have taken care of it himself. Rozzy J was even then a super 1930s classic. She was stilled moored with the yacht club fleet until just a few years ago and still was kept absolutely in Bristol condition.

George had a great springer spaniel who loved to dive full speed off the dock. He had no fear of loud noises but would jump right into a batch of exploding firecrackers and bite them. Occasionally, a neighborhood dog or cat would "adopt" us and hang around begging for ice cream or other tidbits, and a few customers brought their dogs swimming with them. The first time I ever saw Mary Lynch Hoyt (the mother of one of the charter members), she was riding her horse on the beach, accompanied by their big black Saint Bernard.

About a month before the hurricane (1938, of course) while driving down from Darien, I saw a Muscovy duck hit and killed by the car ahead of me. Not wanting to let him be smashed in the road, I stopped and threw his body in the trunk of the car. At the Bluff, I removed him from the trunk and laid him on the ground. A little while later, when we looked out, he stood up and walked away. He adopted us, and somebody fed him. The night of the hurricane, he disappeared. We figured that he had been killed or carried far away. But like a nine-lived cat, after about ten days, he showed up again. As winter came on, Ballard Cantrell, whose yard backed on Goodwives River, took him home and made a little shelter beside the brook. Then in the spring, "he" started to lay eggs and sat on them. Since there was no mate, the eggs were sterile. So Ballard bought a dozen fertile eggs and they all hatched.

A History of the Rowayton Waterfront

Another resident, Joseph A. Kilbourn, also shared some of his recollections of days spent at Hickory Bluff with former commodore Clive Morrison. The following is what he had to say.

> *My family lived up the street on Bluff Avenue in the old Victorian house adjacent to the old Farrell Estate. My grandfather, William J. Kent, had started coming to Hickory Bluff for the summer in the 1890s from the Park Slope area in Brooklyn, where he was a close neighbor and friend of James A. Farrell.*
>
> *As I was growing up in the 1930s, I spent a good bit of time hanging around the Hickory Bluff Store and listening to reminiscences of George [Schlichting] and his brother, Harry. In particular, I remember George recalling that in 1926 or 1927, Rudy Vallee appeared at the Roton Point Amusement Park Casino [Neville Bayley Park] for a singing engagement, which drew over six thousand people. Before starting his gig, Vallee stopped at the Hickory Bluff Store to fill up the tank of his four-door Packard Convertible Phaeton automobile. It was a big thrill, according to George, to meet him.*
>
> *The interior of the old store was wainscoted and probably had not been changed from the time it was built.*

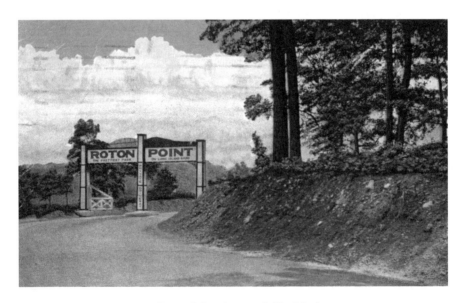

The vehicle main entrance to Roton Point. *Courtesy of Clive Morrison.*

Hickory Bluff and the Rowayton Yacht Club

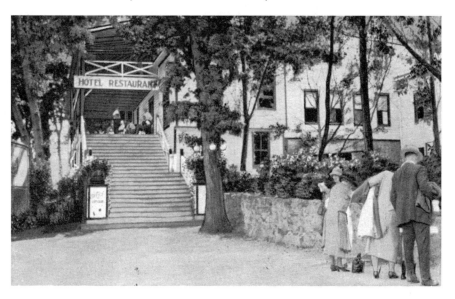

The casino entrance at Roton Point. *Courtesy of Clive Morrison.*

George filled the walls with pictures and signs. I particularly remember the photographs taken in 1934 of an automobile driving to Sheffield Island on the ice, as that winter there was a freeze all the way out to Green's Ledge Lighthouse.

George, who was an inveterate fisherman, would invite an unsuspecting customer (me, once) to open the icebox, which was located on the right side of the building as you faced the water. In those cases, the door opener would be greeted by a thirty- to thirty-five-pound striped bass staring him in the face, which George had caught on one of his early morning forays.

Snapper fishing off the old Bell Island Bridge was terrific. You would first purchase a pint of spearing from George, which was packaged in a white ice cream container, pick the appropriate tide and sit on one of the old eighteen- by eighteen-inch crossbars that supported the trusses of the bridge. It was an ideal spot for a bamboo pole. One of my earliest recollections was catching snappers, bringing them home and eating them twenty-five minutes after pulling them out of the water. No fish was ever fresher.

During the winter months, when the store was closed down (George usually went to Florida for a month or two), we used to occupy our time after school by climbing the roofs of the unoccupied houses on Bell Island. At that time, there were only about ten winter residents, the rest of the people being summer residents.

A History of the Rowayton Waterfront

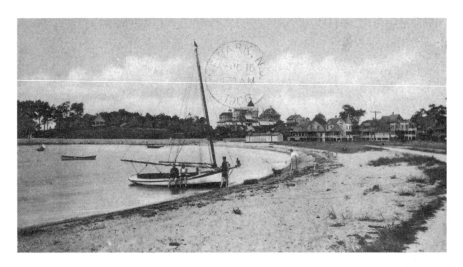

Swimming at East Beach on Bell Island. *Courtesy of Clive Morrison.*

George's brother, Harry Schlichting, built in 1940 his dream sailboat, which was a very wide-beamed twenty-six-foot cat boat. He kept it near the White Bridge in Rowayton. It featured a real fireplace. Regrettably, for Harry, he did not fireproof the fireplace, and the first time he lit a fire in it, the boat was consumed by fire.

I used to go with Ballard Cantrell and Billy Gray, and, occasionally, Ed Bouty, to Ram and Sheffield Islands to collect fiddler crabs for the blackfish enthusiasts. The Cable and Anchor Reef out in the sound was the favored blackfish fishing grounds.

Occasionally, George found it necessary to seine his own beach for spearing when there was a run on snapper bait. I often helped Ballard and Billy do this. It required the eviction of the swimmers from the beach and one person to walk out chest-high in the water with the other person knee-deep and walk the width of the beach with the seine net. It was amazing how many spearing would be trapped.

I remember sailing with Bob de Courcy in a Friendship sloop with my sisters and the Leo brothers. It was an ideal boat for a crowd of people, and the favored spot to sit was the bowsprit, which, in a heavy sea, would dip into the water.

I used to do a lot of fishing with George McKendry Jr., known as "Hitch," and Charles Leo. Hitch also permitted me to maintain an eel pot off his dock in Farm Creek. However, it did not last long, because eels, long a Rowayton staple in the Depression days of the 1930s, were not very salable by me to our neighbors.

Hickory Bluff and the Rowayton Yacht Club

Today's Rowayton Yacht Club at Hickory Bluff was created in 1986 by a group of local residents who wanted to maintain the preservation of their local maritime heritage and also protect their unique access to Long Island Sound. The original Hickory Bluff Store building is currently used as the Rowayton Yacht Club's official clubhouse.

The beach, picnic area, piers, launches, assorted collection of vessels moored in the anchorage and, of course, view are all in step with the days of old. By all accounts, the members of the Rowayton Yacht Club have succeeded in keeping the quaint atmosphere and humble approach to waterfront living alive and well at Hickory Bluff.

7
BELL ISLAND

The Summer Resort at the Tip of Rowayton

Bell Island is not, as one might presume by the name, in reality a true island; rather, it is a peninsula by actual definition. Geography shows us that it is made up of one large rock, unevenly worn down in spots and covered with soil and sand from the effects of wind, waves and changing weather conditions throughout the centuries. The topography is that of a high bluff located on the northern side, with a gradual slope leading to its lowest point on the southern side.

It is believed that members of the Raymond family from Salem, Massachusetts, were the first to purchase the island back in the 1740s. For nearly a century, it went by the name of Raymond Point.

In 1837, after being passed down through the Raymond generations, a daughter named Mary Ann Pennoyer acquired the family property at the tip of Rowayton. Harmon Bell from Pelham, New York, made an offer to Mary Ann Pennoyer in 1852 to purchase the island. Pennoyer accepted the offer at the agreed-upon sale price of $727.18.

From that moment on, the name was changed to Bell Island and has remained so ever since. Over the years, there have been other spellings, such as Belle Island, but the proper way is Bell.

Harmon Bell was primarily interested in the plentiful oystering grounds that surrounded Rowayton and the island. Ultimately, Bell would purchase other properties in the Norwalk area solely for the rights to neighboring oyster beds.

Over the years, the Bell family would sell off parcels of their property on the island to other prospective homeowners. One of those people was a man

by the name of Samuel Olmstead, who purchased a tract of land in 1856. Included in the transaction were two sloops (*Vito* and *Elizabeth of Norwalk*) and a ship.

Another new property owner on Bell Island was Lewis Raymond, who secured several of the parcels. By doing so, he once again brought the original Raymond name back to the island.

In 1881, Joel Foster, Timothy Foster and Levi Mansfield created a business partnership, believing there was the potential to build a seasonal resort on Bell Island. With that in mind, they immediately began to buy numerous parcels of land from Lewis Raymond.

The Foster brothers, along with Mansfield, found their newly acquired properties to be somewhat neglected. Poorly pruned fruit trees, thick walls of weeds and overgrown shrubbery were everywhere, often blocking a clear path to the water's edge. The only structures to speak of were an old farmhouse and three cottages. The three owners proceeded to turn the farmhouse into a forty-room hotel, complete with a spacious dining area large enough for a full house of guests to enjoy at one sitting. Unfortunately, in 1889, a fire broke out and burned the hotel almost completely to the ground. In 1890, the owners began construction on a new hotel, which they would name the Bell Island House. Three new cottages were added in 1892.

Later, the name of the hotel was once again changed, this time to the Elmendorf Hotel, or as many people affectionately called it, "Summer Rest."

The Elmendorf Hotel was expanding as a business and soon introduced the additions of two bathhouses and a horse stable. Eventually, the Fosters and Mr. Mansfield decided to move the entire hotel to a completely different location on the island. There, it acquired yet another name—the Summit House—and shortly after assumed the new role of boardinghouse and ice cream parlor.

Bell Island was quickly becoming the place to be during the summer season. The Foster brothers and their partner Mansfield continued to build many new homes on East Bluff (also known as the "Point of Rocks"). When the Fosters finished construction on their own house, the brothers named it Retsof, which is simply their last name spelled backwards.

Around 1892, the three business partners began to sell some of their island properties. Before signing on the dotted line, however, each potential homeowner had to agree to the following clause: "If any owner is caught selling spirituous liquor of any kind, the land would be confiscated." That clause held up quite well for the most part, except for the time that one future deed holder contested it and the wording was ultimately deleted from his contract.

Bell Island

Upon Timothy Foster's passing in 1905, the executors of his estate put up a public notice of land for sale, taking out ads in both the *Danbury Evening News* and the *Evening Sentinel*. This proved to be a great marketing success as most of the property sold almost immediately. During the same time, Joel Foster, in conjunction with his late brother's estate, donated the Point of Rocks to Bell Island as a gift so that residents and guests could enjoy its unique water views, great fishing grounds, ideal picnicking area and the natural solitude that had made it so popular in the first place.

Around 1860, New Haven resident and owner of the lucrative Stevens Oyster Company, Captain William Isaac Stevens (Captain "Ike"), purchased property on Bell Island for his brother. Ironically, Captain Stevens's brother declined the generous gift, stating that it was too difficult to get on and off the island and that it was not an easy place to live year-round. In essence, he was correct in his observations. As late as 1881, the only reasonable way to approach the island was to row from Wilson Point or, at low tide, to go from Roton Point across Pine Point to Crescent (South) Beach. Since Pine Point was separated from Bell Island by water and marshland, it became necessary for planks to be laid in order to make for a somewhat easier, and drier, crossing.

Another way to access the island at the time was to catch a ride aboard the steamer vessel *Media*. *Media* was skippered by Captain Rowland and ran daily from Norwalk to Wilson Point and Bell Island.

Bell Island was, without a doubt, a challenging place to live at certain times of the year. Rainy springs brought muddy walkways and almost impassable roadways. Without the luxury of electricity, oil lanterns were hung to light the way around the island. Mr. Benedict, the first person to remain on the island throughout the winter months, became the "official lamplighter and caretaker of the Island." Every evening from late autumn to early spring, Mr. Benedict would begin his rounds of lighting lanterns at 5:00 p.m. and then would return to extinguish them at 7:30 p.m.

During the late 1880s, a man locally known as "Grampa" Brown owned a rather large piece of property near the entrance to Bell Island. Grampa Brown was an avid gardener, and his property was the only one on the island that boasted a flourishing bounty of flowers, vegetables, cherry trees, pear trees and apple trees at that time.

Children were always welcome to use Grampa's lavish green lawn to play games such as tennis and croquet. Eventually, Grampa built a house on the great lawn for his daughter, who followed in her father's footsteps by maintaining it as one of the most beautiful pieces of property on the island.

A History of the Rowayton Waterfront

By 1885, there were quite a few regular summer residents who enjoyed living on Bell Island. With more and more foot traffic going back and forth, everyone was in agreement that the construction of a pedestrian bridge between Hickory Bluff and the island itself would be a good idea. The new bridge was completed that same year, and then in 1892, the bridge was expanded so that it would be able to accommodate horse-and-buggy traffic. Another motivation for building a larger bridge was so the postman would be able to make his daily delivery to his customers more efficiently.

Shortly after the bridge was updated, the *Media* discontinued its boat service to the island. It was eventually sold to a gentleman who utilized the vessel for clamming.

During the late 1800s, a man by the name of Phil Smith constructed the Montewesse Hotel, along with his wife, who also managed the business. The hotel was located across the street from the Summit House. Oftentimes, the guests staying at the Montewesse would wander over to the ice cream parlor to enjoy a midafternoon or after-dinner treat. Next door to the ice cream parlor was Mr. Pinkas's Candy Store, another favorite spot of the locals.

A few years after the Montewesse opened its doors, it came under new ownership. John Todd purchased the existing hotel and changed the name to Todd's Cottage, for obvious reasons.

Around 1900, the Haviland Cottage, which was owned by a Mrs. Hickey, was converted to the Soundview Hotel. Mrs. Hickey managed the hotel with her sister, Katherine Farrell. Without fail, the hotel's thirty-person limit was easily met by the beginning of the summer.

Mrs. Hickey had the reputation for being an outstanding hostess and first-rate cook, serving delectable meals and Sunday dinners that were the talk of the island. Some of the esteemed guests of the Soundview Hotel included the likes of Guy Lombardo and many other notable bandleaders who would stay there during their concert engagements at Roton Point Park. Even Fio Dell'Agnese, the manager of the famed Waldorf-Astoria, was a regular guest at the hotel during the warm-weather season.

When Mrs. Hickey passed away, she left the Soundview Hotel in the hands of her sister, who continued to run it as a boardinghouse for quite a while on her own. Eventually, though, it became too much for her to handle solo, and she opted to sell the property to a family who used it as their private home.

The early 1900s was a time of easy living on Bell Island. You would hardly find anyone indoors during the summer months. Even on rainy days, residents and guests would simply lounge on their porches and enjoy the

Bell Island

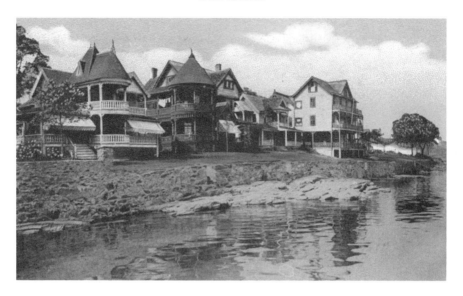

Shore cottages on Bell Island. *Courtesy of Clive Morrison.*

enticing views of the island and the warm, salty air carried by gentle breezes from Long Island Sound.

Boats and trolley cars were the primary means of transportation for these annual visitors, who came with arms full of all of the bare necessities. Grandparents, aunts, uncles, mothers, fathers, children and family pets could all hardly wait to get started on their summer vacations on their little corner of Long Island Sound.

During the early morning hours, a woman who went by the name of Aunt Sally would make her way over from Rowayton with a cart full of her fresh, home-grown vegetables to sell to the island residents. Later the same day, Aunt Sally would come back with the empty cart to collect the remnants and then return home to feed them to her pigs for dinner.

Other local merchants who frequented the island on a daily basis included Chester Fitch, the Norwalk grocer and town butcher. After going door-to-door to take orders in the morning, these business owners would then return in the afternoon with all of their deliveries.

The baker also got in on the action, arriving at the bridge each day by horse and buggy, which was loaded up with cakes and cookies. He was clearly the favorite of all the children, as they eagerly waited for the friendly baker to arrive.

A History of the Rowayton Waterfront

The women of the houses never needed to go into town to shop, since everything they required was conveniently delivered to their doorsteps. This was a luxury that they all enjoyed and always appreciated.

Each home on Bell Island had its own water pump. Since the water from the pumps was not appropriate for drinking, the children would go to one of the two wells located on the island to collect their families' drinking supply.

Coal stoves were used to heat the water for washing dishes and clothes. A woman from town would come by one day of the week to do the clothes washing for many residents and would return the next day to do the ironing. The charge for this service was seventy-five cents a day.

One of the daily chores for the children was to put together a colorful bouquet of daisies for their parents' porch. Since the island was abundant with daises, this was an easy task to fulfill. After the morning duties were completed, it was time for socializing and beach going. On any given day, elegantly dressed men and women would assemble waterside to bask in the sun. (Unlike today, sunbathers during that era were mostly covered in long-sleeved and full-length apparel and often wore hats or used parasols to block the strong rays of the sun.)

Just beyond the water's edge, an abundance of white sails could be seen dotting the horizon. Sailing, cruising and informal racing were popular pastimes back then, as were canoeing, fishing and clamming.

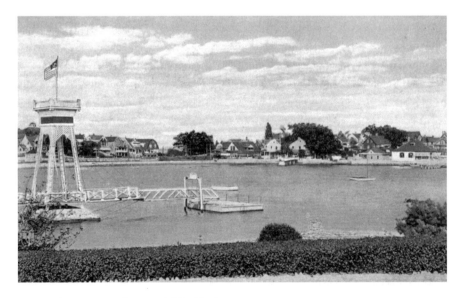

A view of Bell Island. *Courtesy of Clive Morrison.*

Bell Island

The children spent many of their daylight hours swimming, climbing on the haystacks on the vacant hillside lot, playing at the old windmill, scaling the rock ledges or picking apples from any number of trees scattered about the island.

Porches, parlors and pianos were the three musts for most of the homes around Bell Island. Beautiful maple trees lined the walkways and roadways.

By 1905, many of the summer residents had begun winterizing their homes so that they would be able to extend their visits to the island further into the year.

One of the newer residents in 1905 was a successful movie producer by the name of Lloyd Selwyn. Selwyn was well known for the extravagant parties he threw for such distinguished guests as the famous Barrymore family, Marilyn Miller, Laurette Taylor, Bert Lahr and a variety of other Hollywood talent. Some of Selwyn's movie-star friends, like silent film and Broadway stars Dorothy and Lillian Gish and Broadway and screen star Jerome Cowan, enjoyed the island so much that they eventually bought properties of their own.

One of the unique characteristics of the Selwyn home was the lower-than-average location of the doorknobs. When he was once asked about this, Selwyn replied, "They were put on for the convenience of Tom Thumb," a popular dwarf who performed for the Barnum and Bailey Circus at the time.

Quite often, people could be seen swimming just off of the Selwyn estate in the hopes of catching a glimpse of some celebrity walking the grounds.

One of the largest landholders on Bell Island was William Hanna, a lumber merchant. With expansive acreage to do with as he pleased, Hanna decided to establish a hotel on part of his waterfront estate. Eventually, his hotel idea would evolve into the Bell Island Country Club.

In 1913, Mr. W.C. Smith, the owner of the Indianapolis Baseball Club and brother of "Pittsburg Phil" of racetrack fame, made an offer to William Hanna to purchase all of his property, including the Bell Island Club. After finalizing the deal, Mr. Smith converted a swamp that was located on the property into tennis courts. By adding some attractive landscaping, the tennis courts quickly became a popular spot. Since tennis was a favorite pastime back then (as it is today), the courts were rarely ever vacant.

With so much interest in outdoor sports at the time, it was a natural segue when Mr. Smith introduced the proposition to host the Baseball and Tennis Championships of Connecticut Summer Resorts at the Bell Island Club.

With two small private homes on his estate, Mr. Smith was once asked, "Why don't you build a nicer home for your family?" In considering that

The clubhouse and tennis courts at the Bell Island Club. *Courtesy of Clive Morrison.*

suggestion, Smith thought that instead of building an entirely new house from scratch, he would simply join the two existing homes with a substantially sized room to create one huge structure. The new common area was utilized as a billiard room and for hosting the grand parties that were becoming regular happenings at the Smith residence.

Continuing work on his expansion project, Mr. Smith also added on a few bedrooms above the common area for guests to stay over.

During Prohibition times, the Smith house became a dinner club, with the large room connecting the two original houses becoming a colossal-sized dance floor for the many local bands that played there.

When Mr. Smith passed away, all of his property was sold to Jerome Cavanaugh, a real estate investor. Ironically, Cavanaugh had the connecting room removed and the two original houses renovated back to the way they used to be. Cavanaugh also converted one of the servant's cottages into a garage for his private collection of automobiles.

Mr. John Gloetzner Sr. was a hardworking businessman with Columbia Records and did extensive traveling for his job. While in Europe one year, Gloetzner met Martha Zeigler, a young woman who was studying with the opera. The couple began dating and eventually married. Upon their return to the United States, the newlyweds purchased property on Bell Island. Having all of his new wife's belongings and furniture shipped stateside,

Bell Island

Gloetzner's new home on the Rowayton shoreline soon reflected a rather eclectic style. The couple had a passion for entertaining and put much effort into hosting elegant and fashionable dinner parties for their friends, family and colleagues.

During that time, it was common to see horse stables, multiple-car garages and servant cottages on the privately owned estates located on the island. There were many affluent residents during the early 1900s who owned property and required these amenities to sustain their wealthy lifestyles and eccentric hobbies. Rolls Royces and Packards became normal sights on the roadways. As a matter of fact, cars were so important to homeowner Mr. Harlan Wright (he especially liked the Packards, of which he owned several) that he put up an entire string of garages on his property.

Charles Stevens, who purchased some land from Harlan Wright, was a talented stonemason who had no problem securing work on the island. Cobblestone walls were one of his most frequent requests. Much of the stone that he used was rowed over by boat from Sheffield Island. A large amount of his original work can still be seen today around Bell Island. When Stevens was not busy creating a stone masterpiece, he ran a horse-and-buggy taxi service to and from the island.

Whether they earned their living in the corporate world, on Broadway or through skilled self-employed labors, all of the residents worked together to create a comfortable and friendly community.

The turn of the century saw some major advancements in technology. The telephone was one such product, and it was so much of a luxury at the time that the only resident to have one in his home was Charles Stevens.

Electricity was another new invention. Soon, the old lights that lit the roadways were replaced by electric streetlights that were automatically turned off at midnight or on moonlit nights. Aside from the streetlights, only the well-to-do could afford electric lights in their homes.

And, of course, the introduction of the automobile, or "horseless carriage," was one of the more amazing new creations. The first automobile owner on Bell Island was a lumber merchant named William H. Clark, who drove up in his brand-new car in 1907.

In 1910, the City of Norwalk voted to build an official roadway that would run through the western section of Bell Island. The new road would successfully connect Hickory Bluff to South Beach and then to Roton Point.

During that same year, William Clark acquired swampland on the island, known locally as the "salt meadow." His plan was to dig it out and refill it as a pond. He completed the pond, but unfortunately, mosquitoes attracted to

the newly man-made pool of water created quite an issue. Clark eventually filled in the pond with dirt and then gave the land to Bell Island to use as a common area. It was named Clark Park, and a stipulation of the donation agreement stated that "on said land no building, shed, booth or platforms or structures of any kind shall be erected, and no benches or seats shall be placed…Any breach shall work a forfeiture of every right to this property."

In 1919, after World War I had finally come to an end, most of the activity on the island seemed to focus on the Bell Island Club. Card parties, concerts, plays, dances and a variety of other social activities for both younger and older adults alike were in abundance at the popular club. The on-site concession stand served hamburgers, ice cream and candy and was busy all day and all evening long. Interestingly, theatrical plays were staged on the balcony, with the audience seated at ground level. When the balcony was not being used for a performance, rocking chairs were set up to allow the older residents to sit, relax and enjoy all of the action going on below them.

When the Roaring Twenties rolled around, social activities stepped up even more. A New York newspaper wrote an article about Prohibition in Rowayton and titled the story "Bell Island, the Bootleggers' Paradise." Everywhere one went, case after case of "spirituous liquor" could be found. Booze flowed like water, and it seemed that everyone was "making whoopee." Speedboats could be heard powering around the harbor late at night as they made their deliveries throughout the area.

Jazz music was becoming vogue. Women were tossing out their corsets, shortening their dresses and cutting their hair. The flapper was introduced, and inhibitions were disappearing.

On Labor Day, the summer residents would form a long snake dance as they left the clubhouse for the last time of the season. They would then work their way around to each house on the island, stopping along the way to take a sip out of one of the many punch bowls that were waiting for them on nearly every porch. By the end of the goodbye dance, everyone was in a rather gala mood, thanks to all of the liquor consumed during the exuberant departure.

In 1921, Mr. Charles Hogan formed a holding club of the Bell Island Improvement Association and ultimately bought the Bell Island Country Club. In 1936, after fifteen years of being the center for all things social, the club closed its doors for the final time. The clubhouse remained empty, feeling the effects of the Depression years.

Eventually, Mr. Palinkas of the Norwalk Hat Company purchased the abandoned club property and renovated it into a private residence.

Bell Island

During the 1930s, a realtor by the name of Mr. Crimmins decided to take a chance on the swampland located at the southwest side of the island. His plan was to develop a group of small cottages that he would then turn around and sell. In order to make the wetlands sturdy enough to support a house, Mr. Crimmins, with the help of his father-in-law, Mr. Seeley, invested in oyster and clam shells at fifty cents a yard and proceeded to fill in the swamp area.

Mr. Crimmins then constructed a series of cottages with small yards, each with its own beautiful vista of Long Island Sound. The financial risk that he initially took paid off well. The houses all sold, and the new homeowners could not have been happier.

Today, Bell Island continues to flourish as a unique community within Rowayton. Families still spend their summers on the island, and year-round residents are much more common than they were during the formative years. Access to and from the island is no longer an issue. Sailboats and powerboats remain constants on the horizon, beaches are regularly filled with sunbathers and the innate sense of calm that has been a characteristic of the island for centuries abounds even now. With all of the changes that have occurred over the years, Bell Island has been able to successfully maintain its easy living atmosphere.

8

REX MARINE AND NORWALK COVE MARINA

Louis J. Gardella Has a Vision

In the mid-1930s, when Louis J. Gardella, owner of the Gardella Trucking Company, decided that he wanted to buy a boat at cost, he figured that probably the best way to go about accomplishing something like that would be to start his own boat business. Gardella already had a connection to the water, as his trucking company had been regularly transporting freight by boat from New York from the early 1920s well into the 1930s.

After doing some research, Gardella found that he was most impressed with the Chris Craft boat line, and on April 7, 1936, he officially became the Norwalk representative for that company. His first delivery was to himself, and he appropriately named his newest acquisition *Rigger*, reflecting his work as a truck rigger.

Gardella set up his marine shop on Route 1 in Norwalk at, of all places, a gas station. It wasn't exactly a waterfront location, as it was at least a few miles from the shore, and it certainly did not fall under the typical venue from which to sell boats. However, Gardella had a plan.

Gardella had been keeping his eye out for quite a while for some potential waterside properties, and 1940 proved to bring with it some intriguing possibilities. After some consideration, Gardella made an offer on the old Seal Ship Oyster House on Water Street in South Norwalk. Upon signing on the dotted line, Gardella moved his boat inventory down by the Norwalk Harbor, named his new location Rex Marine and began selling to and servicing a new nautical clientele.

A History of the Rowayton Waterfront

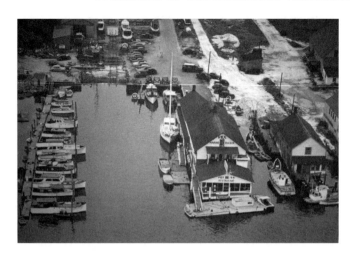

Rex Marine Basin. *Courtesy of Bill Gardella Jr.*

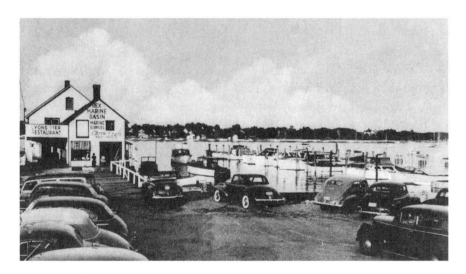

The Lyons Pier Restaurant at Rex Marine. *Courtesy of Clive Morrison.*

Soon thereafter, Gardella and a friend of his, Neal Lyons, opened up the Lyons Pier Restaurant in the same complex.

By the early 1950s, Lyons had decided to step away from the Lyons Pier Restaurant. This allowed the opportunity for E.C. Jones, who already owned a successful restaurant in Coconut Grove, Florida, to become part of the Norwalk waterside dining experience. Once Jones partnered with Gardella, the name of the restaurant was changed to simply the Pier. Jones was a big hit as an interactive manager among the patrons, partly due to the fact

that he always walked around with his assistant manager (a parrot) on his shoulder and also because he knew a thing or two about the food industry.

Always one to recognize a potentially worthwhile opportunity, Gardella soon saw a chance to expand his waterfront real estate. On the other side of the harbor in East Norwalk, Gardella had owned property at Ascension Beach since the 1930s. When the time was right during the early 1950s, Gardella was able to secure a rather substantial extension of that land.

For this particular project, Gardella brought in two other partners, and together the three men purchased the land for approximately $100,000. Part of the area was approved for the zoning permits required for building lots, which was what the men had been hoping for when they were initially considering going forward with the transaction.

Gardella's timing was brilliant, as the boating business really started to boom by the mid-1950s. Seeing a need to expand boat storage space, both in and out of the water, Gardella had attempted to build docks along Ascension Beach. However, after a brief period trying it out with fifteen slips, it became painfully apparent that, due to its unprotected exposure to Long Island Sound and the harsh weather that often hit the shoreline head on, the Ascension Beach locale was not the most ideal place to set up a marina.

Moving forward to plan B, Gardella sought the zoning permits that he needed in order to start clearing out the extension of property that he had previously purchased with his two colleagues. Part of the renovation process would include pumping out a rather large pond that sat on the land and then sectioning it off so he would be able to create some solid ground to work with.

Relying on his trucking knowledge, Gardella already had a plan in mind of how to go about it and was ready to put it into action as soon as he

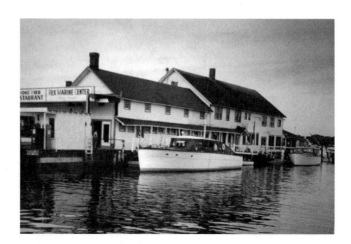

Rex Marine and the Lyons Pier Restaurant. *Courtesy of Bill Gardella Jr.*

received the green light. First, Gardella placed a commercial-sized diesel pump to siphon the water out of the pond. Next, he had to quickly build a dam to keep the water out. Once he was down to plain hard earth, Gardella used a one-yard shovel scooper and a Caterpillar loader to remove the tons of gravel that were now in his way.

Always the businessman, Gardella sold the gravel for a dollar a yard to anyone who was interested. Much of the rock went to the construction of the new Interstate 95 highway and the landfill effort at Calf Pasture.

Once everything was cleared out and the pond was contained, it was time to start building the actual marina. Gardella's resourcefulness once again came in handy as he used lumber from old one-hundred-foot freight barges that were being dismantled in New York City to build his docks. Made from yellow pine, the timbers were four inches by ten inches by thirty feet and were just what Gardella was looking for.

As luck would have it, Styrofoam had recently come onto the scene. Gardella had a hunch that that material would be perfect for keeping his yellow pine afloat. His hunch was right, as those original docks would ultimately last for the next thirty years.

After completion, the new development was named Norwalk Cove Marina, and the design of a sound marketing plan was next on the to-do

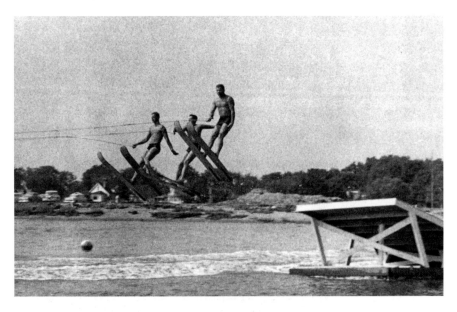

Ascension Beach Water Ski Club members performing one of their tricks. *Courtesy of Jill Leonard Tavello.*

list. One of Gardella's brainstorms was to host a promotional hydroplane race. There had already been a popular one that ran from Albany, New York, to New York City, so Gardella had a blueprint from which to start. The Norwalk-based route would take competitors from Greens Ledge to Bridgeport Harbor and back again.

That would take care of the racers for a while, but what was Gardella to do about the spectators who had to wait for the boats to return? With the creative wheels always spinning, Gardella came up with the idea that he would bring in the Weir's Water Ski Club from New Hampshire to put on an exhibition to keep the crowd entertained.

After that initial show, water-skiing began to quickly gain popularity in Norwalk. Gardella's five sons eventually started up their own water-skiing association and named it the Ascension Beach Water Ski Club. For several years, members of the club competed and put on their own demonstrations around the Norwalk area. The Gardella boys set up a slalom course and ski jump off of Peach Island. They used the low float that had been constructed for a ferry to Chimon's Island as a water-ski launch. The calmer water of Charles Creek was often used as a stage for some of their more fancy tricks, such as their five-man pyramid stunt. At the height of the Norwalk water-skiing phenomenon, the members of the Ascension Beach Water Ski Club

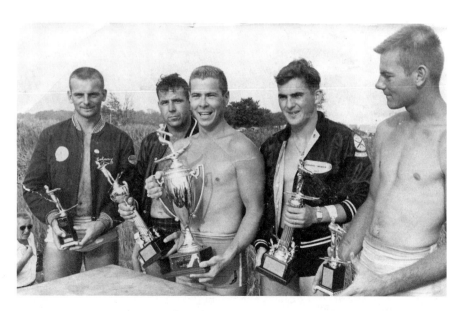

John Gardella, "Sonny" Canton, Stew Leonard Sr., Dick Robinson and Jimmy Gardella of the Ascension Beach Water Ski Club. *Courtesy of Jill Leonard Tavello.*

purchased their own Chris Craft ski boats and traveled all over the Northeast to participate in events.

A few other projects that Gardella was involved with included a fireboat for hire, a first-of-its-kind rack storage arrangement and a saltwater swimming pool.

The fireboat idea was born when Gardella had the notion that he would like to charter out a party boat as a business venture. When he learned about an old fireboat that was for sale, Gardella jumped on the opportunity. After making a few necessary renovations to the vessel, his new charter fleet of one was rented out for parties and fishing excursions. Docked at Rex Marine, the boat saw a good amount of action in the beginning of its career. During one of its trips, however, a fire broke out and all on board were forced to jump ship. Luckily, everyone made it out safely, but the vessel did not fare quite as well. The fireboat's short-lived career ended up in flames—an ironic twist of fate, one must agree.

The rack storage venture came about when Gardella realized that he needed to make the most out of a limited amount of space. Gardella had come up with a plan to build a series of racks on which to store boats. The only problem was how to get the boats on the racks. Calling on his trucking experience once again, Gardella used a hoist to lift the boats off of a small forklift truck and then gently place them in their appointed spaces on the racks. This approach worked out very well. Many consider Gardella to be the first to implement this boat storage concept.

Gardella also had the idea of using salt water instead of fresh water for a swimming pool. He constructed an adult pool and a children's pool on

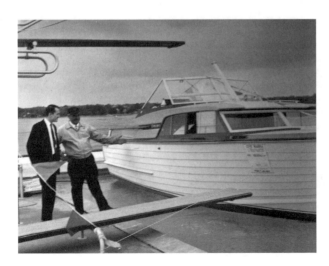

Louis J. Gardella showing a boat floating in the saltwater pool at Ascension Beach. *Courtesy of Bill Gardella Jr.*

Rex Marine and Norwalk Cove Marina

his property at Ascension Beach during the late 1950s. He then added a clubhouse, cabanas and showers and named his new development the Ascension Beach Pool Club. Since the adult pool was the only one equipped with a filter for the salt water that was being pumped in from Long Island Sound, every night Gardella would have to drain the children's smaller pool and then refill it with water from the larger pool. This approach, although a bit time-consuming, worked just fine.

Gardella was clearly a savvy and forward-thinking businessman. Other accomplishments to his credit include being one of the first to use a crane to lift boats in and out of the water and being one of the co-founders of the Norwalk chapter of the Coast Guard Auxiliary during World War II.

Today, Rex Marine and Norwalk Cove Marina continue to thrive as full-service yachting facilities and are both still owned and managed by the Gardella family.

9
MYSTERIES AND TREASURES

A Missing Ship, the Curse of Captain Kidd and a Bounty of Precious Jewels

Imagine you are standing on the picturesque shores of Norwalk, Connecticut, on a summer afternoon sometime between 1907 and 1942. Long Island Sound lies just within your reach and is dotted with the classic yachts of the era, the most impressive being the large steamships that carry passengers from New York to Maine and select ports in between.

The early to mid-1900s were considered by many to be the Golden Age of Transportation, a time that represented one of the most romantic periods in maritime history.

One of the more prestigious and popular steamships during those years was the now-famous SS *Belle Island*. With an imposing length of more than two hundred feet and weighing in at a staggering 842 gross tons, the SS *Belle Island* could easily transport sixteen hundred guests on the three massive decks to wherever they desired to go.

The SS *Belle Island*'s primary route at that time included a regular run to the docks located at Roton Point in Rowayton. With a major amusement park located right on the property at Roton Point, it proved to be the perfect destination for fun-seekers, and the "Lady Belle" (as the ship was often referred to) quickly became the chariot of choice. For nearly twenty-two years, it was a standard fixture on the local horizon.

The ship was so much in demand, in fact, that the owner eventually decided to expand and created the old Steamer Belle Island Company with a few other interested investors.

A History of the Rowayton Waterfront

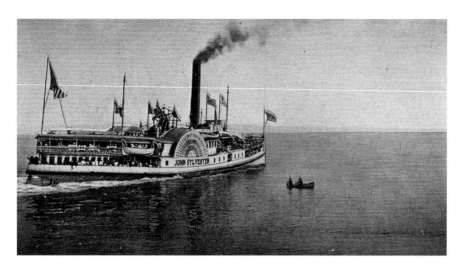

One of the many excursion boats that frequented Roton Point. *Courtesy of the Roton Point Association.*

However, as the effects of World War II were becoming more apparent by late 1941, all stocks were eventually sold back to the owner, who in turn chose to accept an offer for his pride and joy from the United States Navy.

Shortly after the Lady Belle was officially enlisted, the government determined that it would be best utilized as a supply ship due to its extremely shallow draught and great carrying capacity.

During its first few months under government ownership, the SS *Belle Island* was sent to the Amazon River as it collected and transported rubber from various jungle ports. This particular assignment was crucial toward developing one of the leading industries at the time.

As the efforts of World War II started to increase, the U.S. Navy decided to use the SS *Belle Island* to perform even more important duties. Now this is where the mystery really begins.

As it sailed off to England from its assignment on the Amazon, the details of the remainder of the SS *Belle Island*'s military career suddenly, and curiously, become unclear.

After it was commissioned to England, there appears to be no further recorded information in regard to the former Norwalk pleasure ship. Apparently, the only other mention of the Lady Belle from that point on regarding its whereabouts did not come about until June 5, 1945, when a newspaper article reported the following:

Mysteries and Treasures

Nostalgic memories of trips between N.Y. and Roton Point Park aboard the good ship S.S. Belle Island *were rudely shattered this week with the announcement that the 216-foot steel vessel had gone down to the bottom of the English Channel in the service of her country.*

Now, in and of itself, that sentence would probably be depicted as simply a rather sad ending for a glorious, celebrated and beloved ship. But if you then take into account the following information that was discovered later, the plot decisively thickens.

Following is a letter from the United States of America General Services Administration written on February 24, 1976, in response to a query sent by Dr. Henry J. Gloetzner regarding the SS *Belle Island*:

The enclosed form 6779 describes the vessel documentation records and our findings therein concerning the BELLE ISLAND *(Official No. 224714).*

The BELLE ISLAND *was requisitioned by the War Shipping Administration on February 10, 1943 and transferred immediately to the Navy Department, to the War Department, and back to the WSA, and then to the British Ministry of War Transport. Sometime during its transfers from one agency to another the name of the vessel was changed to* COL. JAMES A. MOSS. *It did not, however, become physically available to the British Government in time to be used. As it was found to be suitable for service on the Amazon River the vessel underwent repairs and its title was transferred to the Rubber Reserve Company on April 12, 1943.*

The Rubber Reserve Company was owned by the United States Government. Its functions relating to the development of natural rubber in Brazil were transferred to another Government-owned corporation, the Rubber Development Corporation, about the time that the COL. JAMES A. MOSS *arrived in the Amazon River. The charter for the latter corporation expired in June 1947. The few extant records of both corporations are now in the National Archives and have been examined.*

The last reference to the COL. JAMES A. MOSS *that we have found relates to its transfer to Honduras flag and registry in 1943 and its charter to SNAPP Lines, a Brazilian firm. In October 1946 a settlement between SNAPP Lines and the Rubber Development Corporation involved the return of six unnamed river steamers to RDC. If the* COL. JAMES A. MOSS *had been one of these, it should have been declared surplus and turned over to either the U.S. Maritime Commission or the State Department's Office*

of Foreign Liquidation for sale. No reference to such an action was found in the indexes to the Maritime Commission minutes, or the records of the State Department.

And here is a reply, dated March 17, 1976, to a separate inquiry received by the National Maritime Museum in Greenwich, London:

Dear Madam,
Thank you for your letter of 7 March. I regret that we have no account of the Col. James A. Moss, *(ex-*Belle Island*), being lost in the Channel during May 1945. The contemporary issues of Lloyd's List do not mention any ships sunk in the channel during that month. The volumes of Lloyd's* Register of Shipping *for the years 1943/44 to 1950/51 list the British Ministry of War Transport as the* Col. James A. Moss's *owners. Unfortunately we have no details of the vessel's ultimate fate, nor do we have any photographs of her.*

To add to the ambiguity, similar responses were received after additional query letters were sent to both the United States of America General Services Administration in 1975 and the National Maritime Museum in London, England, in 1978.

So what exactly happened to the Lady Belle? Is it, in reality, sitting at the bottom of some distant ocean, with no records of any surviving crew or its precise location? Why are there, presumably, no photographs after it retired from civilian life? What, specifically, were its tasks while in English waters?

In the early part of 2006, Nancy Borge, history committee chairwoman of the famed Roton Point Yacht Club in Rowayton, was collecting information about the history of the property for the upcoming first History Day event. As she sorted through old papers and records, the incredulous details of a supposed missing steamship slowly, yet most definitely, were becoming more and more apparent by the minute. Delving deeper into the newly discovered missing boat saga, she soon learned that it would not be an easy mystery to solve.

Borge, along with many of her fellow club members, continue to maintain a front-burner attitude about the historical steamship. And that's a good thing, since their persistent efforts are the only remaining chance we might have to uncover the rest of the missing pieces to the puzzle and learn the true story about the SS *Belle Island*'s supposed demise.

Mysteries and Treasures

Many unanswered questions continue to linger pertaining to the fate of this great lady of the sea. One of the most obvious, and more baffling, remains: "How is it that one can lose a ship so grand?"

Legends of lost pirate treasures have entertained the imaginations of many seafaring souls for centuries. Just hearing the names Blackbeard, Black Bart, Henry Morgan and Calico Jack can send shudders up and down one's spine. Fantastic tales from all over the globe continue to fill the pages of storybooks that delight readers of all ages.

With so many to chose from, one of the more chilling sagas comes from an incident in the Norwalk area that was presumably experienced by two young men while they were out on a treasure hunt just off the shore of Charles Island. Apparently, during their search for the abandoned gold and silver trinkets that supposedly had been buried years before by none other than the infamous Captain Kidd, something strange and unexpected occurred.

Upon discovering a sealed chest hidden far beneath the island's surface, the men suddenly heard a shrill cry coming from behind them. As they turned to see what had caused such a spine-tingling scream, they could hardly believe what they saw coming toward them. Descending from the sky came a headless body wrapped in a sheet and covered with flames. Terrified, the treasure seekers ran for their lives and left the island as fast as they possibly could.

After returning safely to the mainland, comfortably far away from the ghastly creature, the two men decided that they must have hallucinated the entire encounter as a result of being out in the hot sun for too long. Feeling confident that it was their minds simply getting the best of them, they made plans to go back the next morning to reclaim their find.

Once daylight had broken, the two climbed back into their boat and rowed out to the island—only to discover that there was no sign of their treasure chest, the shovels they had hastily dropped or the hole that, less than twenty-four hours earlier, they had painstakingly dug.

The accounts of Captain Kidd's escapades up and down the Connecticut shoreline don't stop there. As legend has it, Captain Kidd's ship, the *San*

A History of the Rowayton Waterfront

Antonio, anchored up the Connecticut River one dark and foggy night as the captain and his crew set forth to bury their most recent acquisitions.

After successfully placing his wealth deep in the ground, Captain Kidd announced that there would be a drawing of straws to see who would stay behind to guard his riches. Just moments after the short stalk was pulled, the poor shipmate holding the fateful stick was shot to death and dropped into the hole along with the treasure. After covering everything up, Captain Kidd sailed on, leaving the sailor's body as a warning to any thieves considering stealing his hoard.

Since that notorious night, many residents along the Connecticut shoreline have reported seeing a large ancient vessel flying a flag with a skull and crossbones sailing across the water and then inexplicably disappearing from sight.

There are plenty of other haunting descriptions that trace back to the era of Captain Kidd and his adventures as he passed through our local waterways. And there is solid history behind those incidents; it is a known fact that Captain Kidd and other buccaneers did, indeed, traverse Long Island Sound. Many speculate that if they were looking for a place to stash their stolen treasures, what better hiding place than in the abundant numbers of hidden coves, inlets and islands of Connecticut?

To add to the mystery of Captain Kidd and his exploits, there is a rumor that has survived through the generations (and has yet to be disproven) about a resident of Norwalk and a collection of Spanish coins left by the notorious pirate. The story is told that during the 1930s and earlier, many long-standing citizens could remember hearing their grandparents speak about a Captain Joseph Merrill who had three consecutive dreams showing him the exact location of a presumably fictitious treasure. Not truly believing that there was anything credible about the dreams, Captain Merrill did, eventually, make his way to the hypothetical spot so that he could finally put an end to the silly visions that were keeping him awake at night. Well, as fate would have it, he actually did find riches beyond words. To this day, nobody can understand why Captain Merrill would have had these visions or why he was chosen to be the recipient of this peculiar booty, but that does not change the fact that he truly did.

Was Captain Kidd ever in Norwalk? Did he anchor his ship off one of the many islands that surround the local shoreline? Did he choose one, or more, of the hidden inlets to bury his silver and gold? We may never know the answers, but there are certainly plenty of convincing stories that would lead one to believe that he did, indeed.

Mysteries and Treasures

On the morning of May 6, 1853, a train from the New Haven Railroad embarked on one of its regular excursions through Connecticut. On board for this trip was Thaddeus Birke, a well-known and successful English importer of fine jewels and precious stones. Birke was on his way to attend a formal engagement that was being hosted by Boston millionaire Nigel Massey.

With him, Birke was bringing along two wooden trunks full of diamonds, pearls and gold and silver jewelry that he was planning on showing to perspective buyers at the high-profile event. The approximate value of what he was traveling with came to $250,000—a rather high amount, especially back in those days.

As the train was approaching the town of Stamford at about 10:00 a.m., the steamship *Pacific* was, at the same time, preparing to pass under the Norwalk River Railroad Bridge. As the drawbridge operator saw the approaching vessel, he began the proper protocol to open the bridge so that the ship would be able to pass safely through.

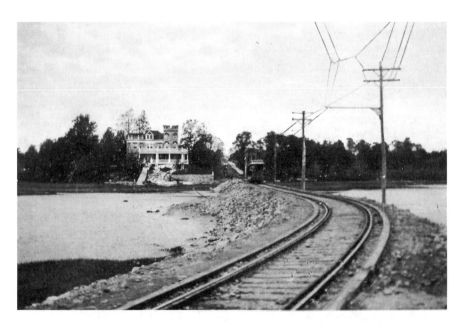

Railroad tracks that ran through Rowayton. *Courtesy of the Roton Point Association.*

Unlike other bridges that were designed to have two ends of the roadway open upward, the Norwalk River Bridge operated by moving the midsection of the road so that it would rest parallel to the water below.

After signaling any oncoming trains that the drawbridge was about to be opened, the operator began to activate the system to allow the waiting *Pacific* to go on through.

After the vessel was safely out of range, the operator began the procedure for closing the bridge. As he did so, he was shocked when he turned and saw the New Haven Railroad train traveling at top speed down the track straight for the open bridge. For some reason, the train engineer and crew had not received the signal that they should not pass over the bridge. Once the engineer and his staff realized what was about to happen, they jumped off the train into the river.

The train, now running completely unmanned and out of control, appeared to gain speed as it barreled closer to its impending doom. Eventually, it drove off the track. Two of the cars went directly into the river, while a third dangled precariously on the edge.

Bystanders watched in horror as cargo, mail, baggage and passengers fell one after the other into the river below. It was, by far, the worst railroad disaster in history to date.

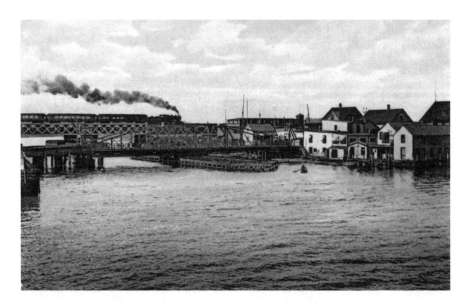

The railroad bridge passing over the Norwalk River. *Courtesy of Clive Morrison.*

Mysteries and Treasures

Forty-six people were lost in that tragedy, among them Thaddeus Birke.

For days afterward, people tried to salvage whatever they could that had not already been washed out to Long Island Sound. Although much was recovered, some objects were never found. Two of those objects were the trunks carrying Thaddeus Birke's $250,000 fortune of precious jewels. Whether they floated out to sea or sunk to the murky bottom of the Norwalk River, we may never know. As far as anyone can determine, they have yet to be found.

10

A BIT ABOUT OYSTERS

Going as far back as the early 1600s, Wilson Cove, Roton Point, Bell Island and the surrounding coastal communities of Norwalk have boasted a rather abundant natural supply of oysters. When the settlers first came to the area, they quickly learned that the Indians who were here before them had already recognized the advantages of the plentiful oyster stock right there at their fingertips. It is believed that oysters were the primary food source for the Native Americans at that time. Over the centuries, residents have found literally hundreds of thousands of old shells that were left behind from the days when Indian tribes abounded in Norwalk. In some instances, man-made walls of empty oyster shells, measuring six to eight feet thick, have been discovered.

In addition to being used in the construction of walls, barriers and other containment structures, the shells of the oysters were often used as an exchange for money, or wampum.

When the white man arrived, the Indians were the first to show him how to rake, or tong, for oysters in shallow water along the floor of Long Island Sound. The tongs that they used were made up of two long pointed rakes that were hinged together in order to open and close efficiently, similar to a pair of scissors or clippers.

As time went on, the settlers wanted to be able to harvest a deeper-water crop. In order to achieve this, they needed to invent a dredge of sorts that would enable them to reach greater depths with ease. After trying out a few rough ideas, they eventually came up with a dredge system that was

constructed from a rectangular iron frame. It was about four feet across with long, sharp edges (or teeth) on one side of it and a substantially sized open bag made of iron and cord on the other side.

The settlers would then bring the dredge out by boat and drag it along the bottom of the sound. This method allowed the sharp teeth to shake up the oysters that were resting on the sea floor. As the oysters began to float, the bag would then follow behind and scoop them up into one neat pile.

Around 1800, a few forward-thinking oystermen decided that it might be a good idea to start planting some oyster beds to ensure a continual crop. Although most people believed that the opportunity provided by the sound, with its natural supply, was unlimited, this particular handful of ambitious fishermen did not want to unwisely rely completely on that presumption.

During the early 1800s, selling oysters to customers outside of the town limit was beginning to grow into big business. Salesmen would head out from Norwalk on a daily basis, driving their wagons filled with oysters and clams to neighboring communities. They would accept butter, pork, grain, cloth and, of course, cash in exchange for their wonderful delicacies from the sea. It did not take long before they started experiencing great success with this new type of commerce.

For the most part, the vessels that were being used to dredge in deeper waters included schooners, sharpies, scows, sloops, rowboats and even canoes. When the local oyster industry was booming during the mid-1800s, Norwalk claimed boasting rights for having the largest and most diverse oystering fleet in all of Connecticut.

The sharpies, so named because of their sharp bows, featured a wide and flat bottom, which made them conducive to carrying large loads in shallow depths. The sharpies were generally twenty-seven to thirty-five feet in length and could be handled either solo or with two crew members. They are believed to have originated in Connecticut and eventually went on to gain much popularity throughout the rest of the New England and Atlantic states, even as far south as Florida. Scows were another flat-bottomed vessel designed for transporting large catches.

In 1874, Captain Peter Decker, the founder of the Peter Decker Oyster Company, was the first to introduce steamboats into the oyster industry. Although many of his friends and colleagues thought he was crazy to even try it, Captain Decker went right ahead and converted his thirty-one-and-a-half-foot sloop *Early Bird* into a steam-powered vessel. In the beginning, it was a slow process to come up with the right combination of parts that would work well on the sloop. At first, Captain Decker used a boiler and an

A Bit about Oysters

engine to turn the drums that hauled the dredge lines. Although the steam was able to generate the dredge in that manner, it was still necessary to use the sails to move the boat through the water.

As Decker continued to try and find ways to fine-tune his concept, the addition of a small screw to the steam-powered engine proved to give extra strength to the sails. This allowed Decker to sail *Early Bird* even in light wind conditions.

An even more efficient design came about when Captain Decker, along with his brother, installed a larger boiler and a more powerful engine. By doing this, *Early Bird* was able to operate completely under the full support of steam. To lighten the boat and make it more ergonomically sound, the bowsprit, mast and sails were eventually removed. After that, the boat was able to haul two dredges at a time and catch as many as 150 to 200 bushels of oysters a day.

Even though Captain Decker's invention was mostly met with skepticism and suspicion, there were some oystermen who found the idea to be quite intriguing and began renovating their own vessels into steam-driven boats.

When Sea World sent Captain Decker an inquiry in 1881 about his new, and at that time unorthodox, approach to oystering, he responded:

> *I put steam power in my sloop for the purpose of towing and hauling my oyster dredges in March, 1874, and found her capacity for catching oysters augmented about ten times without increasing her working expenses. In 1876, a boat for the same purpose was built at City Island, New York, and in 1877, another at Norwalk, making three all told and now I can count twelve in active operation and several in process of construction. I have 56 acres of hard bottom oyster ground which I was unable to use owing to its being infested with starfish, and I could not keep them off until I put steam in my boat; then I cleaned them all away, and in doing so, I cleaned the bottom to such an extent that it received the young oyster spat, and now the ground is covered with oysters and free from starfish.*
>
> *When I commenced to rig my sloop into a steamer, the rest of the oystermen laughed at me and said I was a fool; but after they found that I could catch more oysters than they could, they went to the legislature and had a law passed to prohibit steam dredging on natural beds. But instead of destroying, I claim that the use of steamers will create natural beds, which I think I have fully demonstrated by cultivating the 56 acres of ground mentioned above.*

Soon thereafter, a state law was passed limiting oyster dredging by steam-powered vessels to just two days a week. By 1883, all steam-driven dredging on natural beds was prohibited completely but was still allowed on privately owned beds.

After seventeen years of a productive and successful oystering career, the *Early Bird* was sadly destroyed in a fire. Its fortuitous precedent, though, left a lasting impression on oystering methods for years to follow.

In 1888 and 1889, Norwalk became the main oyster source for Europe. Oysters were carefully gathered and then neatly packed in flour barrels for shipping. The barrel lids were closed tightly and securely so that there would be no opportunity for the oysters to wiggle or shift around, ensuring that they would remain closed throughout their entire journey overseas. This was very important when shipping long distances. J.W. Collins, in the 1891 *U.S. Fish Commissioner's Bulletin*, stated, "If the shells remain shut, the liquid stays in, keeping the oysters alive much longer than otherwise would be possible."

During the latter part of the 1800s, nearly three-quarters of the entire oyster export to Europe came from Connecticut, with Norwalk being a major contributor. The bulk of the oyster-shipping season was from November to May, with almost the entire shipment being sent directly to Liverpool, England. Hoping to impress Queen Victoria, a Norwalk oysterman buffed, polished and shined a special order of oysters so that they looked like shimmering jewels and requested that they be hand delivered to Her Lady Majesty. As the story goes, the oysterman never received a thank-you or an acknowledgement of receipt of any sort, so he could only speculate that somewhere along the way someone must have decided to claim the precious supply as his own.

During that era, there was said to be, on average, as many as 160,000 barrels of oysters shipped abroad annually.

In 1889, Norwalk had more oyster boats cruising its waters than any other town in Connecticut. One report had the total Norwalk count at 208 vessels that year, including those propelled by steam, by sail and by rowing. The second highest number of boats was 111 in New Haven.

That same year showed Norwalk as the leader in total number of bushels of oysters harvested from both public and private grounds, with 275,841 bushels appraised at $215,117. Norwalk was also second in the state in regards to total acres of natural oyster beds, with the town controlling 1,650 of those acres and the state managing 160 of them.

As time went on, the oyster business in Norwalk faced many issues, including boundary laws, bushel limits, size regulations, trespassing policies

A Bit about Oysters

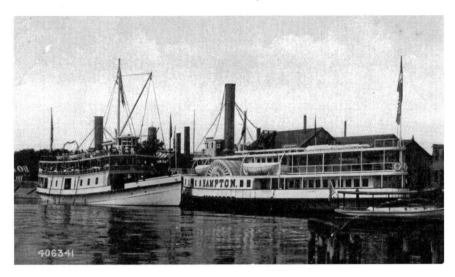

A steamboat dock in South Norwalk. *Courtesy of Clive Morrison.*

and pollution. What was once a thriving and profitable industry eventually experienced an unfortunate, and substantial, decline.

Today, oystering in Connecticut is once again alive and, for the most part, well. Unfortunately, it will never quite reach the level of success that was seen during its heyday as the greatest oyster resource in the world.

II

MULTIHULLS MAKE MARITIME HISTORY

Sailing along the shoreline of Rowayton and Norwalk has long been a favorite pastime for many local residents. For centuries, sailboats have been cruising Long Island Sound in vessels of all shapes and sizes, from the great clipper ships and schooners of a bygone era to modest daysailers and high-tech competitive racing yachts. The allure of the sport needs no formal explanation, especially when it is enjoyed on the picture-perfect waters of the Connecticut coast.

During the early days of yachting, the monohull-style sailboat was the most widely used design, whether captains and crew were traveling great distances or simply sailing close to shore. When the introduction of a sailboat with more than one hull was brought onto the scene back in the 1690s, many people were, understandably, skeptical. An English adventurer by the name of William Dampier was the first to bring the multihull concept to the mainstream after he saw a few of them during his travels to the Bay of Bengal. In 1697, Dampier tried to describe these peculiar-looking vessels. He wrote, "On the coast of Coromandel, they call them catamarans. These are but one Log, or two, sometimes of a sort of light wood…so small, that they carry but one Man, whose legs and breech are always in the Water."

At that time, there was not much interest generated in other parts of the world for the catamaran-style vessel. However, in the mid-1870s, an American yacht designer named Nathanael Herreshoff drew up plans of his own for a cruising catamaran sailboat that quickly caught the attention of many yachtsmen. Speed and stability—two of the vessel's more appealing

characteristics—along with an innovative hull design, helped it to attract a new interested audience.

In 1960, Norwalk resident and local yacht designer Art Javes came up with a fresh and novel approach to the already existing multihull blueprint. That year, the Aqua Cat would make its mark as a first-of-its-kind mass-produced catamaran. As a direct result of the simplicity, ease of use and relative affordability of the vessel, the Aqua Cat was soon credited with successfully introducing thousands of new boaters to the pleasures of sailing during the early part of the 1960s.

When Javes initially set out to build his twelve-foot Aqua Cat, his goal was to create a model that would be as easy to assemble as it was to sail. He went about accomplishing this by using foam-filled fiberglass hulls joined together by aluminum tubes both fore and aft. These tubes also doubled as a traveler and were used as a base in which to secure the mast.

After smoothly sliding into a sleeve along the leading edge of the sail, the mast was then supported by an aluminum triangle, whose base also became part of the frame that housed the twenty-eight-square-foot Dacron trampoline deck. Without the complication of any further rigging, along with the fact that there was no boom to speak of, an ideal model of form and function for the beginner sailor was created.

The sail, which is shaped along the lines of a genoa sail, is ninety square feet and is perfectly sized to easily allow for great hull-lift without the intimidation factor that other types of sail rigs present. When Javes was originally considering what style of sail he wanted to use for the Aqua Cat, he decided to get the opinion of his friend and famed boat builder Bill Luders. Having recently learned about the genoa and having a keen sense that it might work well for his latest project, Javes was surprised at the response he received from Mr. Luders when he told him his plan. "Billy Luders laughed when I said that would make a good sail for my catamaran," shared Javes.

Unaffected by the reaction, Javes went ahead and used the idea anyway. Clearly, he made the right call, as it quickly proved to be a great success.

In 1961, Art Javes teamed up with Norwalk-based American Fiberglass Corporation owner Billy Mills to begin going over the logistics of producing the first consumer-purchasable recreational catamaran ever offered to the general public. In 1962, Mills, already sold on the idea, invested $200,000 for a 75 percent interest in the production of the Aqua Cats. For the next ten years, Javes and Mills would produce and sell nearly one thousand Aqua Cats annually. In addition to being picked up by a variety of resorts and parks around the United States, the Aqua Cats were also bought by countless

private consumers. Two purchases of note include a gift from a friend to King Hussein of Jordan at his wedding to Queen Noor and an addition by Bobby Kennedy to the already extensive family fleet in Hyannisport, Massachusetts.

Art Javes has an interesting tale to share about one of his colleagues in the business, Hobie Alter, founder of the popular and successful Hobie Cat Company. Javes recalls their first meeting in detail:

> *The Aqua Cat was the first catamaran he sailed. I met him at a boat show in Anaheim, California. He had the neighboring booth, selling his surfboards. I introduced him to the Aqua Cat. A while later he called me and said, "You're going to hate me," and said he was going into the catamaran business. I said I didn't mind. Having another catamaran around would only help people get the idea that sitting on a boat is better than sitting in it.*

Art Javes and his Aqua Cat have forever made their mark on sailing history. As a point of interest, the Aqua Cat was inducted into the American Sailboat Hall of Fame in 2001. At one point in time, there were an estimated fifty competitive Aqua Cat racing fleets around the country. To date, there have been over twenty-five thousand models sold around the world. And all because of a simple vision by avid sailor and talented Norwalk naval architect Art Javes to create a platform from which to get the word out about the great sport of sailing.

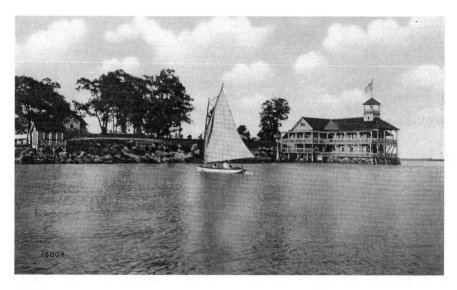

Sailing along the Norwalk shoreline during the early 1900s. *Courtesy of Clive Morrison.*

A History of the Rowayton Waterfront

The Roton Point Club, which was created in the 1940s as an informal beach and waterfront club on the property of the former famous amusement park grounds, began attracting an impressive list of multihull sailors by the early 1950s. Initially a draw for many recreational boaters because of its ideal location and easy accessibility to Long Island Sound, the competitive side of catamaran sailing soon began to gain in popularity at the shorefront club. Countless regattas were scheduled each year, including during the winter months, when frostbiting events were held. One of the most well known and highly anticipated of these competitions was the Little America's Cup.

The Little America's Cup, which was originally named the International Catamaran Challenge Trophy in 1961, was modeled after the larger-class America's Cup contest. During the first eight years of its existence, the United Kingdom dominated the Little America's Cup competitions. Then, in 1969, Denmark claimed the title from a disappointed UK team. Australia would prove to be the winner in the next three events. It was not until 1976 that an American team from California finally succeeded in bringing the trophy to the United States.

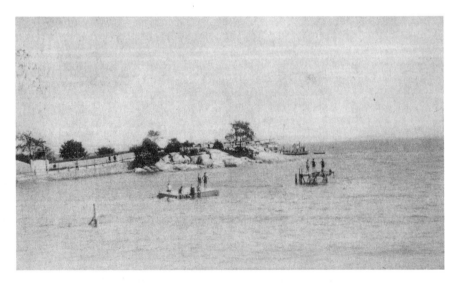

Sunset Rock at Roton Point. *Courtesy of Clive Morrison.*

Multihulls Make Maritime History

In 1972, Roton Point Club commodore Tony DiMauro was determined to design a boat that would put the rest of the Little America's Cup competitors to rest. When DiMauro set out to build a C-class catamaran that would be good enough to vie for Little America's Cup honors, he asked another club member, Dunkin MacLane, to join him in the project. MacLane was a graduate of the Webb Institute of Naval Architecture in Glen Cove, New York, and had already worked on a few multihull designs. The two of them decided to bring in Stamford Yacht Club member David Hubbard, also a yacht designer with multihull experience, to round out their team and give them the best chance for creating a winner.

From 1972 to 1986, the three men worked hard on developing a series of six *Patient Lady* catamarans. DiMauro chose to name them *Patient Lady I* through *Patient Lady VI* after his wife, who, according to him, truly earned the title.

The first Little America's Cup win by a *Patient Lady* was eventually brought home by *Patient Lady III* in 1977, followed by victories in 1978 by *Patient Lady IV* and in 1980 and 1982 by *Patient Lady V*.

When *Patient Lady V* came onto the scene, it was twenty-five feet long with a fourteen-foot beam and a thirty-six-foot wing height. It was the first ever fixed-wing sail design to be introduced to the catamaran racing circuit. Its unique design was modeled after the wing of an airplane. Today, *Patient Lady V* is proudly displayed at the Maritime Aquarium in Norwalk.

Over the years, the Roton Point Club has hosted many successful waterside events that have earned it the reputation for being "the ancestral home of multihull racing in the Northeast…perhaps even the world."

To show his appreciation for all of their support, in 1959, Commodore DiMauro thought that it might be a nice gesture to extend an end-of-the-season thank-you to all of those involved in the many multihull regattas that had been campaigned at the prestigious club over the preceding months. After a full season of high-energy, intense and truly competitive races, DiMauro felt that the onset of a New England autumn was the ideal time to offer the aforementioned appreciation and, at the same time, fit in one last, hard-core competition.

The invitation was to include not only those who participated in the multihull races throughout the year but was also extended to the entire group of Roton Point sailors and their esteemed guests who had sailed out of the club throughout the summer months.

Food, beverages, live music and a weekend filled with great competition, friendly rivalry, intriguing conversation and the most eclectic collection of yachtsmen and yachtswomen on the eastern seaboard made it a successful

A History of the Rowayton Waterfront

Pine Ledge at Roton Point. *Courtesy of Clive Morrison.*

and unforgettable event. It would appear that the initial popularity of that first autumn series set the standard for all future end-of-the-year regattas at the Roton Point Club. As a matter of fact, over half a century later, this annual final season hurrah is still going as strong as ever.

Over the years, Norwalk has been home and host to numerous recognized and accomplished sailors hailing from ports all over the world. The list of nautical events that have been held in Rowayton and along the surrounding shoreline has drawn, and continues to attract, passionate racers and cruisers alike to the picturesque and ideal cruising grounds of Long Island Sound.

12
THE WATERFRONT TODAY

Norwalk has clearly gone through its share of changes throughout the centuries. The effects of the world wars, devastating hurricanes, extensive flooding and the Great Depression were challenges that, through the perseverance and determination of its residents, were overcome. Industry and transportation evolved, improved and grew. Subcommunities along the shoreline developed, adding their own unique charm to the town as a whole.

Today, the coastline of Norwalk continues to thrive. The area of South Norwalk, or "SoNo" as it is often referred to, is currently home to many shops, galleries and an eclectic selection of dining opportunities. The Maritime Aquarium, located along the Norwalk River, draws visitors from all over to its intriguing exhibits, educational programs, fascinating IMAX movies and impressive collection of marine life of all varieties, shapes and sizes.

Both East Norwalk and South Norwalk continue to draw large crowds, especially during the summer months. Miniature golf, sailing lessons, windsurfing rentals, boating excursions, fabulous dining opportunities overlooking the water and family fishing trips are just a few of the activities available to residents and visitors alike.

Rowayton on Five Mile River also offers great seafood experiences, kayaking and boating opportunities, art gallery tours and the chance for quiet moments to just sit down and relax while enjoying some of the most picturesque views of Long Island Sound on the Connecticut coast.

Yacht clubs and marinas continue to flourish along the shorefront, many of them in a style reminiscent of a bygone era. Sheffield Island entertains

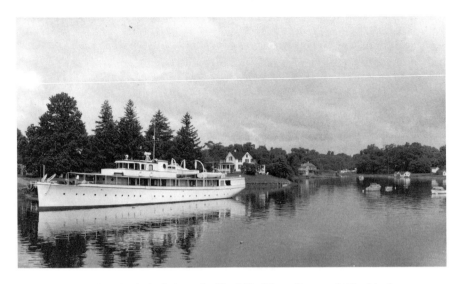

A privately owned yacht docked along the Five Mile River. *Courtesy of Clive Morrison.*

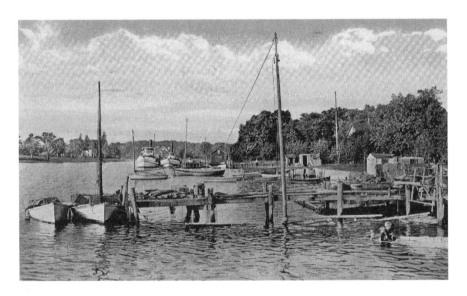

Five Mile River. *Courtesy of Clive Morrison.*

thousands of visitors each year who look forward to seeing, firsthand, its historical landmark. The many other islands that make up the Norwalk chain are as popular as they were when they were first discovered, if not more so. A busy schedule of annual events throughout Norwalk include

The Waterfront Today

such highlights as the International Boat Show at Norwalk Cove Marina, the Oyster Festival held at Veterans Park and the Shakespeare on the Sound festival performed along Five Mile River in Rowayton,

Since its beginning, Norwalk has been a primary destination for people from all over the world. Sailors, cruisers and summer vacationers continue to claim it as one of their favorite spots, just as they have done for hundreds of years.

The Norwalk waterfront is certainly filled with interesting local and maritime history. Apparently, though, the complete story has yet to be told; the residents of this historical town are not content to simply rest on the laurels of their ancestors. Newer generations are making their own headlines, and fresh chapters are being written every day.

It seems that the ol' captain might still have a few more stories yet to tell.

BIBLIOGRAPHY

Bloom, Ralph C., Deborah Wing Ray and Gloria P. Stewart. *Tintype to Snapshot: An Album of Victorian Norwalk*. Norfolk, VA: The Donning Company, 1983.

Danenberg, Elsie Nicholas. *The Romance of Norwalk*. New York: The States History Company, 1929.

Eaton, Lenci. *History of Bell Island*. Booklet, 1976.

Hogoboom, David. *Roton Point: The Prettiest Park on Long Island Sound*. DVD. Ridgefield, CT: Cinestories, 2009.

Jewell, Karen. "Aquarium's Connection to America's Cup." *Norwalk Hour*, January 28, 2010.

———. "Captain Kidd's Local Treasure Trail." *Norwalk Hour*, October 12, 2006.

———. "A Close Island Reprieve." *Norwalk Hour*, April 20, 2006.

———. "Island Hopping Norwalk Style." *Norwalk Hour*, July 13, 2006.

———. "Kayak Tour of the Islands." *Norwalk Hour*, August 1, 2002.

Bibliography

———. "Keeping with Tradition." *Norwalk Hour*, July 11, 2002.

———. "Long Island Sound Is Still Just a Baby." *Norwalk Hour*, July 25, 2002.

———. "The Mystery of the Missing SS *Belle Island*." *Rowayton Historical Society Annual*, 2007.

———. "Norwalk Yacht Club Completes Project." *Norwalk Hour*, May 14, 2009.

———. "Roton Point Beach Ready to Celebrate." *Norwalk Hour*, July 20, 2006.

———. "Roton Point Celebrates 49 Years of Multihull Racing." *Norwalk Hour*, September 25, 2008.

———. "Roton Point Celebrates Multi-Hull Milestone." *Norwalk Hour*, September 17, 2009.

———. "Roton Point's History Day Brings Back Memories." *Norwalk Hour*, July 17, 2008.

Kloman, H. Felix. *Norwalk Yacht Club, A Century*. Norwalk, CT: Norwalk Yacht Club, 1994.

Ray, Deborah Wing, and Gloria P. Stewart. *Norwalk: Being an Historical Account of that Connecticut Town*. Norwalk, CT: Norwalk Historical Society, Inc., 1979.

Raymond, Frank E. *Rowayton on the Half Shell*. Rowayton, CT: Rowayton Historical Society, Inc., 1990.

Websites

D'Entremont, Jeremy. "Greens Ledge Light: History." *New England Lighthouses: A Virtual Guide*. http://www.lighthouse.cc/greensledge/history.html.

———. "Pecks Ledge Light: History." *New England Lighthouses: A Virtual Guide*. http://www.lighthouse.cc/pecksledge/history.html.

Bibliography

———. "Sheffield Island Light: History." *New England Lighthouses: A Virtual Guide*. http://www.lighthouse.cc/sheffield/history.html.

French, Walter. "Connecticut Train Wreck of 1853." Angelfire.com. http://www.angelfire.com/band2/billtrivia/walterfrench.html.

Philips, David E. "Legends of Pirate Gold." Curbstone Press. http://www.curbstone.org/index.cfm?webpage=86.

Roton Point Association. "Roton Point: History." RotonPoint.org. http://www.rotonpoint.org/history/History2.html.

Sailboatdata.com. "American Fiberglass Corp., 1962–1972." Sailboat Guide. http://sailboatdata.com/view_BUILDER.asp?Builder_ID=26.

Schanen, Bill. "Aqua Cat." American Sailboat Hall of Fame. http://www.sailamerica.com/halloffame/aquacat.asp.

Wikipedia, s.v. "Catamaran." Wikimedia Foundation, Inc. http://en.wikipedia.org/wiki/Catamaran.

———, s.v. "International Catamaran Challenge Trophy." Wikimedia Foundation, Inc. http://en.wikipedia.org/wiki/International_Catamaran_Challenge_Trophy.

———, s.v. "Norwalk Harbor." Wikimedia Foundation, Inc. http://en.wikipedia.org/wiki/Norwalk_Harbor.

———, s.v. "Norwalk Islands." Wikimedia Foundation, Inc. http://en.wikipedia.org/wiki/Norwalk_Islands.

ABOUT THE AUTHOR

Karen Jewell currently writes a weekly column for the *Norwalk Hour* newspaper titled "Water Views," which has been running for the past nine years. Its theme centers on anything and everything that has to do with life along the waterfront. Her past work experience includes serving in the position of dock master for five years, working for two years as a yacht charter/yacht sales broker, employment at a prestigious New England sail loft for one year and running a successful boat cleaning business for five years. Growing up along the coastline of Connecticut and having enjoyed summers vacationing with her family along the shoreline of Maine her entire life, Jewell developed a strong passion for the water, boating and just about everything to do with life along the water at a very young age. Her affection for the sea has only grown stronger over the years, and learning about the unique history of the waterfront has been one of her favorite pastimes.

Visit us at
www.historypress.net